IMAGES
of America

AFRICAN AMERICANS OF
MONTEREY COUNTY

**ON THE COVER:** The photograph, taken around 1918, depicts African American boys riding bicycles in their neighborhood of Pacific Grove. They are the sons of Rutherford and Minnie Walker of Pacific Grove. For many children, Monterey has provided open space and freedom to roam and play. African Americans since before the 20th century have migrated to Monterey County for its rich environment and opportunities for land, jobs, homes, and successful family life. (Courtesy of Marguerite McSween Fearn.)

IMAGES
*of America*

# AFRICAN AMERICANS OF
# MONTEREY COUNTY

Jan Batiste Adkins

ARCADIA
PUBLISHING

Published by Arcadia Publishing
Charleston, South Carolina

Printed in the United States of America

Library of Congress Control Number: 2014941576

For all general information, please contact Arcadia Publishing:
Telephone 843-853-2070
Fax 843-853-0044
E-mail sales@arcadiapublishing.com
For customer service and orders:
Toll-Free 1-888-313-2665

Visit us on the Internet at www.arcadiapublishing.com

*This book is dedicated to the families of Monterey County,
especially students seeking information about the evolution of
African American communities throughout Monterey County.*

# CONTENTS

# ACKNOWLEDGMENTS

I am extremely grateful to the many people who have made this book possible. First, I would like to thank the librarians and archivists who provided historical research, consultation, and images for this project: archivist Dennis Copeland of the Monterey Public Library, archivists James Perry and Barbara Brown of the Monterey Historical Society, archivist Sheila Prader of the San Benito County Historical Society, and librarians at the Monterey Free Libraries, Salinas Steinbeck Library, and Castroville Library.

The most essential elements in this book belong to the more than 50 family members who have invited me into their homes to hear their family stories and discuss local history. I especially thank family members of the African American pioneer families for sharing their migration stories and photographs: Marguerite McSween Fern, Douglas Sutton, Mary Ellen Harris, and Wellington Smith Sr. family members. I thank Velma Evans for the many hours spent sharing her family stories during the precious last hours of her life. I have gratitude for Agnes Tebo and Ethel Kelly for telling their family stories of migration from Louisiana and Texas to Salinas in search of a home near the bay.

I am eternally grateful to a few friends who served as invaluable resources for this book: Helen Rucker, for her wisdom and knowledge of political and community issues; Leah Washington, for her professional knowledge of photography; Susan Shillinglaw, for her invaluable ideas, suggestions, and contacts; and Jean Crawford, for joining me on this journey, assisting with the layout, and just being available for advice. Most of all, I want to thank my husband and driver, Walter Adkins, who traveled with me to the many interviews throughout Monterey County, sharing his wisdom. I also want to thank my family members who have supported me during some of the more challenging moments: Jittaun, Christopher, and Christina. I have established many new friendships on my journey of discovering the history of African Americans of Monterey County, whose friendship I will continue. Thank you so much for sharing your family stories and providing a better understanding of life for African Americans in the communities of Monterey County since before the beginning of the statehood of California.

# INTRODUCTION

Unknown to many, African Americans have journeyed to communities in Monterey County to explore, work, or establish homes since as early as the 18th century. *African Americans of Monterey County* examines the history of black explorers, adventurers, and pioneers of the 18th and 19th centuries. Further documentation was done through oral interviews and family stories and photographs of the migration of African Americans in the 20th century to the Monterey Peninsula. This book explores the establishment of a sense of community for African Americans throughout Monterey County. The history of African Americans in Monterey will add to the established history of other ethnic communities within the peninsula and the Salinas Valley. This book depicts the journey of African Americans with the common goal of establishing communities in Monterey County where families could flourish. The story begins with the first known person of African heritage to journey to Monterey.

Since Fr. Junipero Serra led soldiers and priests and Native peoples from Baja to the Monterey Peninsula in 1769, people from various countries have migrated to communities in Monterey County, which was at that time considered Mexican territory. Several African ship workers, such as caulkers (ship maintenance), were aboard a ship during his expedition. Those Africans helped build the Mission of Carmel, among them Alejo Nino. Following Alejo Nino in the 1770s, two governors of the Mexican territory of Alta California in the mid-1830s, Lt. Col. Manuel Victoria and Pio Pico, were of mixed blood and considered mulattos or Afromestizo, meaning of African descent. Even though Mexico maintained a system of classifying people, those of African heritage were neither enslaved nor restricted, as was the case in America.

In the 19th century, many black men and women who were either slaves, runaway slaves, or freedmen journeyed to California. Some were freemen in search of land, gold, or new adventures; some were cowboys or miners who came as slaves to drive cattle or to pan for gold for their owners. Many who arrived as slaves were able to buy their freedom or escape slavery once in the West, since California was not a slave state. Such men as James Beckwourth, James Anthony, Allen Light, Ishmael Williams, and many more lived as freemen in Monterey. However, in rare cases, some, such as Lewis Bardin, lived in Monterey in bondage until after the Civil War. Others migrated to California in search of land to build homes. African Americans from all over America—states in the South, North, and the Midwest—settled in the communities of Monterey, California. Those early African Americans who settled here found the communities more welcoming to those seeking a new life and new opportunities.

During the 20th century, the great migration out of the South brought African Americans to California, increasing the black population by over 400 percent. Others journeyed from the Midwest states of Oklahoma and Arkansas. Some African Americans came from as far as Boston seeking new opportunities. Many African Americans left farms as sharecroppers and migrant workers, or city jobs in the East, to establish new homes and to find new opportunities in the communities of Monterey County. People from around the world were attracted to its mild weather, beautiful coastline, and fishing opportunities. For African Americans, the Monterey Peninsula was a place for employment in the service industries, or, as early as 1902, a place for military service.

*African Americans of Monterey County* is based on oral histories from early-20th-century black families, including the following: Cooper, Walker, Harris, Tebo, Boutte, Niblett, Gatlin, Smith, and Broussard. These families moved to Monterey in the later part of the 1800s or early 1900s, and, in most cases, their stories are documented in this book. Many members of these

families established homes in the communities of Pacific Grove, Monterey, Salinas, and the then unincorporated areas known today as Seaside. After building homes, these pioneers started the first churches for members of the African American community and established social groups and organizations such as the NAACP. They also started a baseball team to compete with black teams in the Negro leagues.

Before World War II, many African American family members who moved to the peninsula encouraged other family members to leave sharecropping and agricultural jobs or unemployment in the South and Midwest and follow them to a new life in the cities of Monterey County. Some family members relocated to the Monterey Bay area as a result of military assignments; others migrated to Monterey to work in the service industry, seeking jobs as domestic workers and drivers. Monterey was known as a tourist destination, and for many African Americans, this meant employment opportunities at the Del Monte Hotel and Hotel San Carlos and in restaurants as cooks and dishwashers. Some found jobs as maids and as domestic workers for wealthy homeowners living in Carmel and Pebble Beach. African Americans worked as drivers and housekeepers for military officers, and others worked in the canneries and at Speckles Sugar Plant.

After Pres. Harry Truman signed Executive Order 9381 in 1948, which integrated the military, many African American servicemen who achieved an officer's rank or who were married to a spouse of white or Asian ethnicity were assigned to Fort Ord, which resulted in a surge in the black population in the Monterey Peninsula. However, Seaside was affected the most, since many communities of Monterey County had established the practice of racially restrictive covenants. Often, African Americans found it difficult to purchase homes outside of Seaside, the county's unincorporated areas. Many black military personnel had been educated at established black colleges and universities, and they often retired to Seaside. Among Seaside's retired military officers were the renowned Tuskegee Airmen and buffalo soldiers.

After World War II, African Americans could rent or buy homes only in Seaside, due to restrictions placed on deeds and mortgages and redlining by bonds; overnight, the city saw a surge in the black population. Life was not easy for black military personnel; they often faced discrimination, and many, after leaving the military, could only find jobs in the service industries as cooks. Some servicemen found jobs in construction, others started their own businesses, and others moved away.

However, with an ever-increasing black population came leadership opportunities. Often wives of military servicemen became involved in political and social activities such as the Women's League of Voters and the NAACP. Monterey attracted professionals with expertise in business. Given the increase in Seaside's African American population, black educators from top black colleges frequently found jobs as elementary and high school teachers in the Monterey Peninsula Unified School District (MPUSD). The MPUSD in the 1960s hired Dr. Charlie Mae Knight, who had to work in the Fort Ord laundry before being allowed to utilize her teaching credentials in Monterey schools as a classroom teacher. She was then called upon to recruit other African American teachers from the South to fill teaching jobs in the district. She opened the doors for many qualified African American educators, who have filled jobs ranging from credentialed teachers and principals to MPUSD superintendent. Seaside incorporated in 1954, and since 1956, African Americans have been elected to city council positions, served as mayors, and eventually were elected to the county board of supervisors. African Americans have held positions on the Seaside City Council since Monroe Jones, who, at 29, ran for city council and won the election in 1956, serving two terms. At that time, Jones was one of three black elected officials in California. Following him, an African American has always held a seat on the city council. Seaside elected Pearl Carey the first African American woman to the city council in 1970, and the first black mayor, Oscar Lawson, was elected in 1976. During this time, the only other city in California that had elected an African American mayor was Los Angeles, which elected Tom Bradley in the 1960s and 1970s.

As a result of the hard work to overcome obstacles and the struggles faced by African American families of the 1800s and early 1900s, many today, standing on the shoulders of their forebears, have achieved great success in music, the arts, television and stage performances, private industry, public service, athletics, the military, and many more fields.

# One

# LIFE IN EARLY MONTEREY FOR AFRICAN AMERICANS

The geographic area of Monterey County was once part of Alta California, a territory of Mexico from 1804 to 1846. This territory was lost by Mexico during the Mexican-American War, which ended in 1848. Before California statehood, men of African descent came to the Monterey coastal or mountain areas of Alta California from Northern and Southern states to hunt, trap, explore, or work for the Mexican government. (Courtesy of Monterey Public Library, California History Room.)

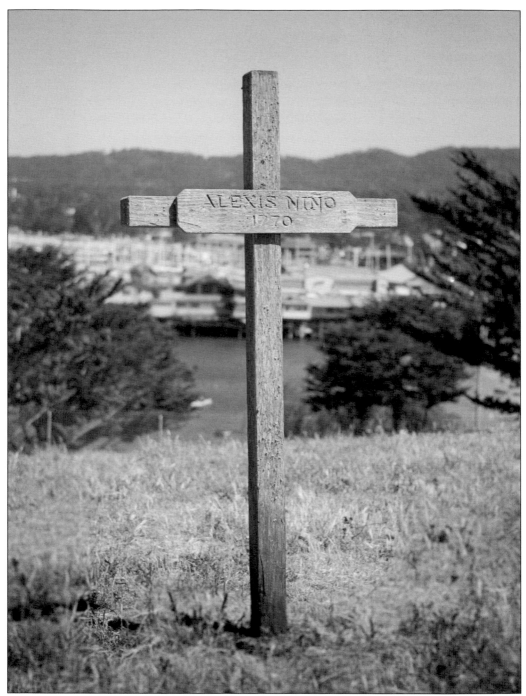

Alejo Nino, an African Spaniard and freeman, was the first black man buried in Alta California under Spanish rule. Nino was a ship's caulker on the *San Antonio*, the ship that brought Fr. Junipero Serra to Monterey in the late 1700s. According to the National Park Service, Nino's death occurred on June 2, 1770. He was buried near the giant live oak under which Father Serra held mass on June 3, 1770. Today, the memorial cross seen here is at the Presidio in Monterey. (Courtesy of Monterey Public Library, California History Room.)

Since before the 18th century, many people of African ancestry fled to Mexico and integrated and assimilated into the Mexican culture. One such man was Allen Light, who was nicknamed the "Black Steward" by his partner in the otter-hunting business in Alta California in the 1830s. In 1827, Light was given sailor protection papers, otherwise known as freeman papers, from a court in Boston. He was required to carry the papers at all times. In 1839, Allen Light became a citizen of Mexico, and the same year, Gov. Juan Bautista Alvarado hired Light as "principal arbiter of the national armada for otter fishing." Light's job was to protect the otters throughout the coastline of Monterey, California. He relocated to San Diego, where he lived from 1847 to 1851. His sailor papers and agreement with Governor Alvarado were buried in the walls of the neighbor's house in downtown San Diego, and in 1948, Allen Light's freedom papers (pictured) and the letter from Governor Alvarado were found in the house before it was demolished. (Courtesy of San Diego Historical Society.)

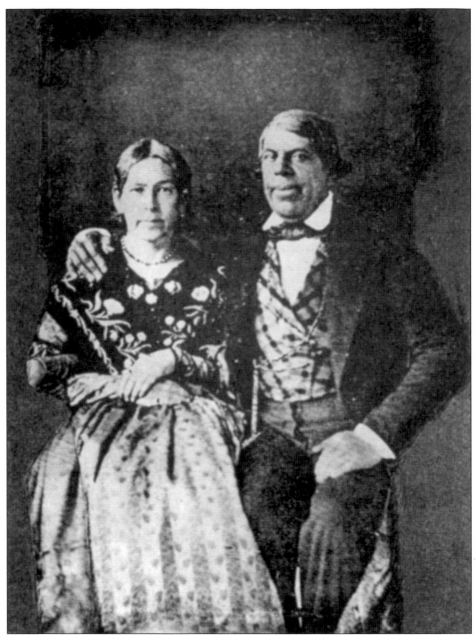

Two governors of the Mexican territory of Alta California were considered Afromestizo, or mulatto. According to historian Jack Forbes in *The Early African Heritage of California*, the first governor was Lt. Col. Manuel Victoria, who served one term in the 1830s. Then, in 1845, Pio Pico was appointed governor of the territory. This 1852 photograph shows Pio Pico and his wife, Maria Ignacia Alvarado. Pico and his family lived in Monterey, which became the capital of Alta California in 1824. His ancestry is said to have included African, Mexican, Indian, and Italian heritage. After the Mexican-American War, Pico became a private citizen and relocated to Los Angeles, where he died on September 11, 1894. His life is remembered by the establishment of a state historic park in Whittier, California, where a statue of Pio Pico is located. (Courtesy of Monterey Public Library, California History Room.)

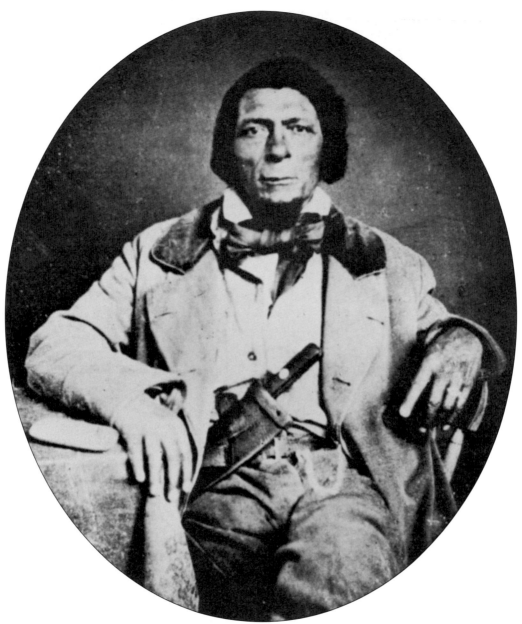

James Pierson Beckwourth was born in slavery in Virginia in 1798 and was freed by his father and later moved to the West. He also lived with the Crow Indians at one time. An explorer, trapper, frontiersman, and adventurer, James Beckwourth during the Mexican-American War served as a mail carrier of American Army government dispatches between Monterey and Charles Dana's ranch at Nipom. In December 1848, he discovered the bloody massacre at Mission San Miguel rancho by Gold Rush marauders. Beckwourth rode to the nearest rancho to put together a posse, then rode north to Army headquarters at Monterey, where he reported the robbery and murders to Lt. William Tecumseh Sherman, adjutant to Gov. Richard Barnes Mason. Beckwourth, who discovered the Beckwourth pass in the Sierra Nevada, was referred to as an "old trapper" and "mail man" according to the biography *Jim Beckwourth*, by Elivor Wilson. (Courtesy of Monterey Public Library California History Room.)

According to US census reports between 1850 and 1870, the early African American population throughout Monterey County, including portions of San Benito County, was fairly small, ranging between 13 and 22 individuals. During the first two decades of statehood, many people migrated to California in search of gold and/or land. The state's overall population grew from 92,000 to over 560,000, and California's black population grew from 1,000 to 4,000; however, the black population in Monterey County remained small. This early population consisted of families and individuals who lived in Monterey, Salinas, and the San Juan area. According to local historian Phil Reader, one resident was Lewis Bardin, a slave brought to Salinas in 1856 by his owner, James Bardin. In the 1850 census, Lewis Bardin is listed as a laborer. James Bardin established a boot-shine stand for Lewis on Main Street in Salinas. It is believed that Lewis was not informed that California was a free state. James Bardin enslaved Lewis for more than 10 years after the Emancipation Proclamation was signed. Once Lewis Bardin became aware of freedom in California, he escaped and established a farm in Corralitos in the Santa Cruz Mountains. (Courtesy of Monterey Public Library, California History Room.)

James Anthony of Rhode Island, a freeman, settled in Monterey in 1850 and established a family home and ferry-crossing business on the Salinas River (pictured) during the California Gold Rush. James came to Monterey with his wife, Mary Hill, of Virginia, his newborn son, and his father, George. The family settled near the town on the old El Tucho land, and James Anthony eventually took over the ferry service at the El Tucho crossing. By transporting people and goods across the river, he was able to earn money to buy a home. In September 1852, outlaws crossed the Salinas River and robbed a town resident, Agapito. The sheriff, Henry Cocks, organized a posse that included James Anthony. It is believed that Anthony killed the leader of the bandits. Then, two years following the shoot-out, a party of seven men arrived at Anthony's crossing and killed his wife, child, father, and two other men staying at the inn and then burned the house to the ground. James suffered the impact of this loss for a long time and eventually moved from Monterey. In 1862, James Anthony died alone in San Francisco. (Courtesy of Monterey County Free Library, Marina, California.)

Ishmael "Bill" Williams (left) was born a slave in Georgia. After the Civil War, he came to San Juan, California, in Monterey County. Although disabled from birth, Williams had tremendous strength. In the 1860s, he was a very successful teamster, transporting 76-pound flasks in a horse-drawn wagon up the New Idria Mercury Mine trail to the company's headquarters at San Juan Bautista. He carried over $10,000 worth of quicksilver. Some considered Williams's teams of horses the best in the land. (Both, courtesy of San Benito Historical Society.)

According to the 1860 census, Ishmael Williams was married, and he and his wife had a son named Ishmael, nicknamed Smiles. After hauling for the mines, Ishmael and his son hauled hay, grain, and wool throughout the county and to the railroad in Tres Pinos and Hollister. Smiles's sudden death as a young man caused Ishmael Williams to break, and he fell on hard times, according to a Hollister reporter. Ishmael hauled until the end of his life, at 92 years old, and he died on April 23, 1905. Many people of the San Juan and Hollister communities had fond memories of "Old Bill" Williams, shown in the below photograph. In the prime of Williams's career as a teamster, he had accumulated a team of 20 horses and wagons. He was known to pay in excess of $400 for hay. At the end of his life, he was penniless, and Hollister residents raised money to bury Ishmael Williams in the Catholic Cemetery. (Above, courtesy of Santa Clara County Parks and Recreation Department; below, courtesy of San Benito Historical Society.)

In this 1890s photograph of Main Street in Salinas, African American men stand in a group on the left. By 1890, the population throughout Monterey County reported as black or mulatto increased by 400 percent, from 13 in 1870 to 65 in 1890. The city of Alisal (Salinas) reports the greatest number of African Americans. Many black men and women migrated from Arkansas, Texas, Oklahoma, and other states to settle in cities in Monterey County in search of new opportunities, work, and land to establish homes. One of the earliest families to settle in Salinas was the Cooper family, some members of which were former slaves. They originally settled in Watsonville in the late 1870s, where Strother Alex Cooper was born in 1875. In the 1890s, he and possibly other members of his family moved to Salinas with his wife, Sarah. The child in the photograph at left is Strother Alex Cooper. (Both, courtesy of Monterey Historical Society, Inc.)

# Two

# African American
# Pioneers of
# Monterey County

During the 1900s, many African Americans migrated to Monterey. Initially, 84 African Americans lived in communities in Monterey County; 27 lived in Salinas. Between 1900 and 1940, the population of African Americans grew by 400 percent; 435 lived in Monterey County. African Americans made up less than 1 percent of the total population. Of the 435, 198 lived in the Monterey area, 119 in Alisal/Salinas, and 77 in Pacific Grove. The remaining 35 lived in San Antonio, King City, Castroville, Gonzales, and Soledad. Alex Cooper (right) of Salinas and a friend are shown here in a wagon. (Courtesy of Monterey Historical Society, Inc.)

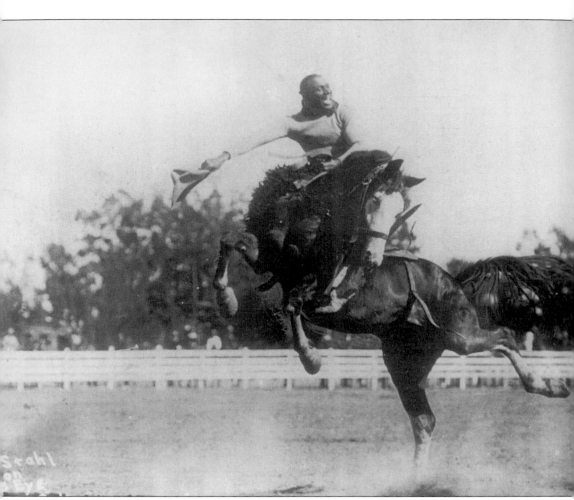

Above, Jesse Stahl, who frequently participated in the Salinas rodeos in the early 1900s, was an African American cowboy and rodeo star. Stahl, born in 1879 in Tennessee, seldom placed higher than third at rodeos. At one rodeo, he placed second, despite clearly being the best, and to mock the judges, Stahl rode a bucking horse called Glass Eyes while facing backward. This event was the highlight of the show. After the demonstration, this ride became known as "a suicide ride." Stahl retired in 1913. In the 19th century, approximately 5,000 African American cowboys rode the cattle trails throughout America. Many participated in rodeos throughout the West. (Courtesy of California Rodeo Salinas.)

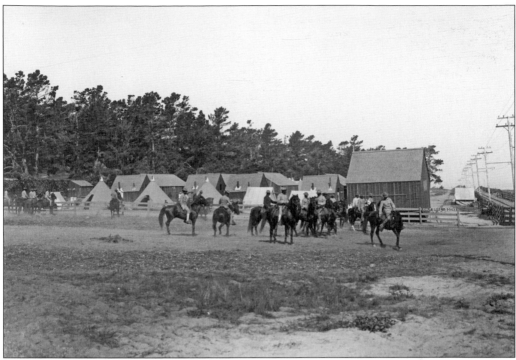

In 1902 or 1903, the 9th Cavalry, 1st Squadron established an encampment above China Point, near Lighthouse Avenue, following service in the Spanish-American War. In this photograph, members of the 9th Cavalry break in their horses while barracks were being built on the Presidio of Monterey. Crowds of Pacific Grove and Monterey residents visited the "rodeos" performed by the famed cavalrymen, the "buffalo soldiers." In this image, two of the soldiers are Henry H. Smith and Louis Smith, brothers of Wellington Smith Sr. of First Baptist Church of Pacific Grove. (Courtesy of Monterey Public Library, California History Room.)

In 1941, the 54th Coast Artillery, an all-black Army unit, manned the heavy guns at Point Pinos during World War II in an effort to protect Monterey Bay, considered vulnerable to Japanese invasion. The local coastal defense network was put in place by the Army. Members of the 54th were stationed in the Point Pinos/Asilomar coastal areas of Pacific Grove. According to the *Carmel Pine Cone*, some artillerymen at the Pacific Grove Lighthouse may have been former players in the Negro leagues. Residents have claimed they witnessed members of the 54th playing ball with Pacific Grove's teenagers during twilight softball league games in their off hours. (Courtesy of Golden Gate NRA, Park Archives, Harbor Defenses of San Francisco Photograph Album, GOGA 38722.)

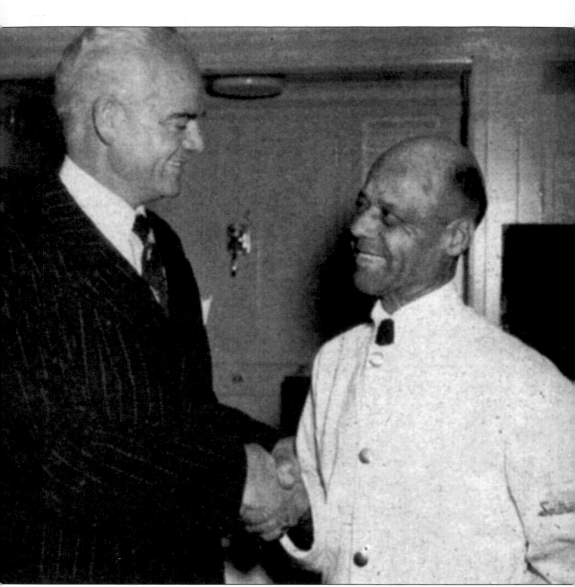

Oliver Millet served as a parlor car attendant in charge of the parlor-buffet car of the famed *Del Monte Limited*. Born on October 16, 1881, in Charendon, Louisiana, he served on the *Del Monte* parlor car since 1915. In the above photograph, Millet is congratulated for his 45 years of service by Southern Pacific president Claude Peterson. Millet was greeted on November 1, 1947, by Dr. Walter E. Anderson on his final run on the *Del Monte Limited* from Monterey to San Francisco. Anderson presented Millet with a wristwatch and other gifts. William E. O'Donnell of the *Monterey Herald*, Monterey mayor Hugh F. Dormody, and Anderson's wife attended the presentation the day of the final run. (Courtesy of Monterey Public Library, California History Room.)

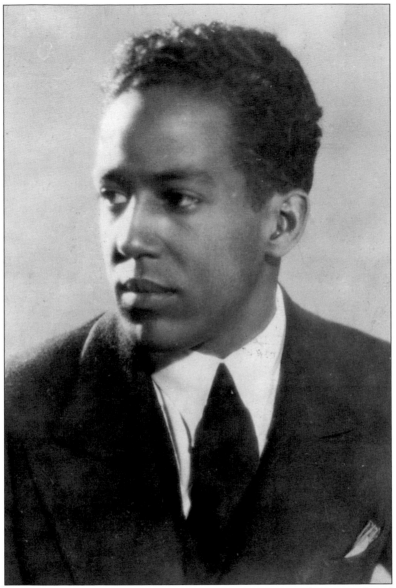

Langston Hughes states in his book *I Wonder as I Wander*, "I wanted very much a chance to be quiet and write. Carmel would give me this chance." So, according to Hughes, he lived for at least one year rent-free in Noel Sullivan's cottage in Carmel-by-the-Sea. There, he was able to complete a series of short stories for his book. Hughes wrote, "after a brief visit to San Francisco, I settled down at Carmel-By-the-Sea that fall and began to work." Carmel, during the years of the Depression, was known as a place visited by artists and writers. Langston Hughes also states, "while in Carmel there were only three colored families . . . and a few others in nearby Monterey." Hughes recalls eating at the home of a cook, Willa White Black. Hughes also states in his book, "Carmel was a 'rejudice-free' place until Fort Ord opened and Southerners came spreading racial problems." It is believed by the family of Leticia Walker McSween that Leticia, while a teen, was a friend of Langston Hughes. He often visited Pacific Grove. (Courtesy of Photographs and Prints Division, Schomburg Center for Research in Black Culture, New York Public Library, Astor, Lenox and Tilden Foundations.)

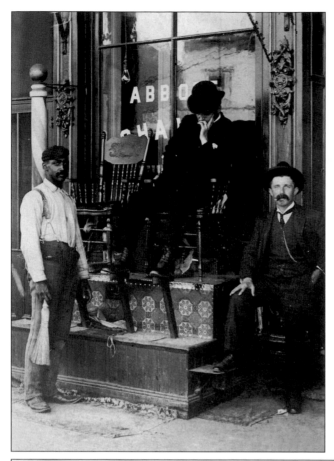

In the photograph to the left, taken in 1911, Strother Alex Cooper, who started his own shoeshine business in front of Abbot House, is standing at left. The Cooper family was one of the earliest African American families to move to the area after the Civil War. Cooper was born in Watsonville in 1875, moved to Salinas in 1900, and went to work for the Spreckels Sugar Company. By 1911, he desired to start his own business. Alex Cooper died in 1923 at 48 years old, and he is buried in the IOOF Cemetery in Salinas, where other Cooper family members have been buried. Seen below is the Spreckels Sugar Company, where Ulysses Cooper and other African Americans worked in the early years of the 20th century. (Left, courtesy of Monterey Historical Society, Inc; below, courtesy of Monterey Public Library, California History Room.)

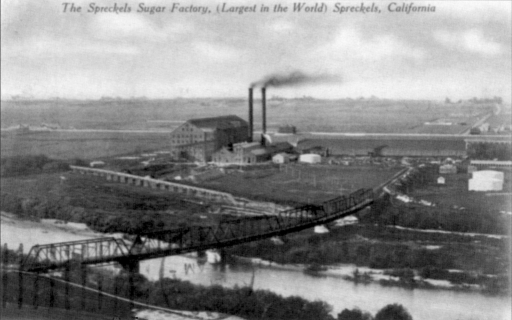

The Spreckels Sugar Factory, (Largest in the World) Spreckels, California

The right photograph shows Sarah Cooper, wife of Strother Alex Cooper. The Coopers raised three children, Leonard, Ignatius, and nephew Ulysses Cooper. Below, Strother Alex Cooper (center) poses with sons Leonard (left) and Ignatius (right). In *Travels With Charlie*, author John Steinbeck recalls going to elementary school and high school with Ulysses, Ignatius, and Leonard Cooper. The Cooper boys graduated from Salinas High School between 1917 and 1919. Cousin Ulysses died from influenza while working at Spreckels Sugar Company right after high school graduation. In the *Salinas Californian* of April 2, 1977, Al Parsons reports that John Steinbeck wrote fond memories about the Cooper family and, later in life, disagreed with common prejudice ideas that "Negroes were an Inferior race." Steinbeck stated, "I thought the authority was misinformed." The Cooper house was located behind John Steinbeck's home, and the boys played ball together in the backyards. (Both, courtesy of Monterey Historical Society, Inc.)

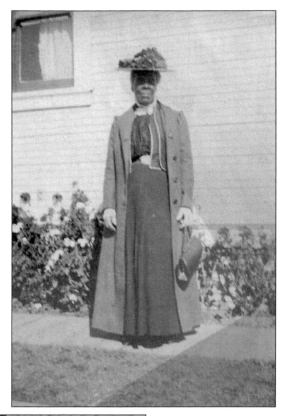

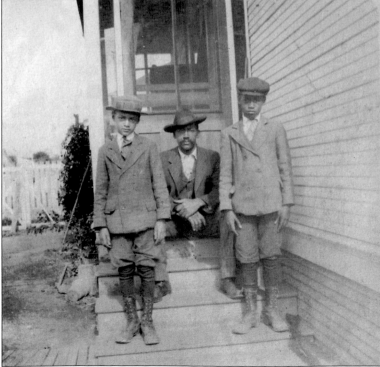

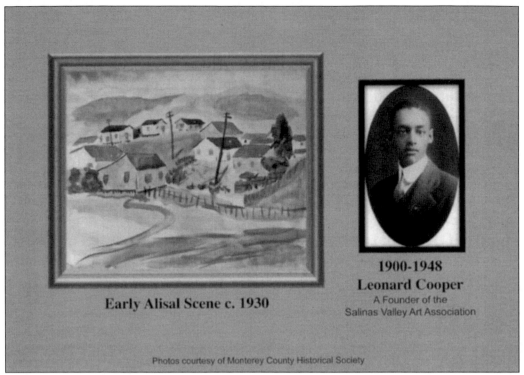

**Early Alisal Scene c. 1930**

1900-1948
**Leonard Cooper**
A Founder of the
Salinas Valley Art Association

Photos courtesy of Monterey County Historical Society

William Leonard Cooper (above), born in 1900, is remembered as a gifted musician and watercolorist who taught music to children, produced musical comedies, and displayed his art throughout Monterey County, Santa Cruz, and Oakland. In 1999, he was described as the best-known African American artist to come out of Monterey County in an article published by the *Herald*. In the below photograph, Leonard (third row, far right) poses with students in his writing class. Leonard Cooper died on July 25, 1948, at the age of 48, the same age of his dad, Strother Alex Cooper, when he died. (Both, courtesy of Monterey Historical Society, Inc.)

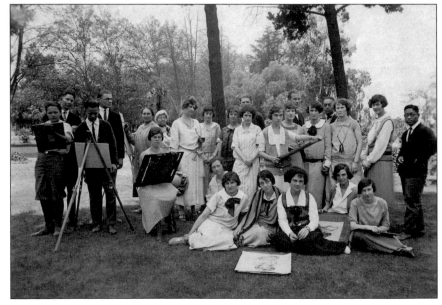

Strother Ignatius Cooper, born in the early 1900s, joined the US Army during World War II. After the war, he returned to Salinas and worked as a postman and, later, as a bank security employee. After getting married, he desired to move back into his house on Maple Street, but he faced a petition from the neighbors, asking him not to move into the house he had owned for many years. The neighbors did not want the black couple to live in the neighborhood. Eventually, Cooper moved into his Maple Street house, but he was saddened by the way he was treated. When told by reporter Alton Pryor of being mentioned in John Steinbeck's book, Cooper replied, "He gives me too many credits." Cooper was described by Steinbeck as a good student: "In arithmetic and . . . mathematics he topped our grades." Cooper served as the Monterey County NAACP president and was a member of the Eastern Star. He died on July 3, 1976, and is buried in the Garden of Memories. (Courtesy of Monterey Historical Society, Inc.)

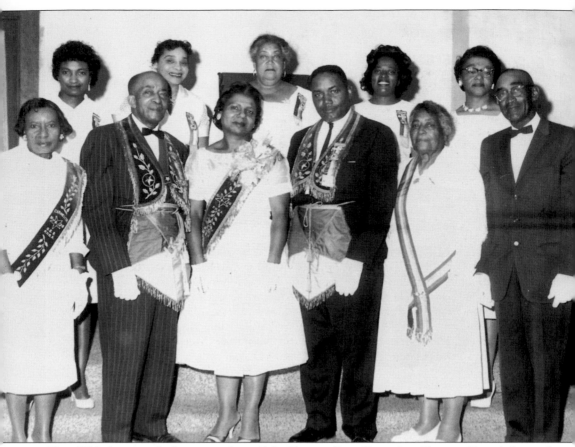

This 1950 photograph shows members of the Eastern Star, Carmelita Chapter. From left to right are (first row) Mattye Cooper; William Ratuff; Pearl Carey, a member of the Seaside City Council; Steven Ross, who served as mayor of the city of Seaside; Frances Guyton of Monterey, daughter of William and Susie Guyton; and Ignatius Cooper; (second row) Joyce McKinney, Mrs. Black, Dorothy Thomas, Elnora Little John, and Christoyla Howard. (Courtesy of Monterey Historical Society, Inc.)

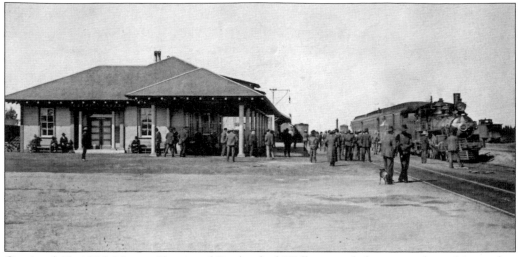

On April 18, 1906, Minnie Davis and Rutherford Walker traveled on a westbound train that stopped in Salinas, California, before going on to its destination in San Francisco. The Southern Pacific depot in Salinas, seen here between 1905 and 1910, is the station stop where, on April 18, 1906, all passengers, including Minnie Leola Davis from North Carolina and Rutherford Haynes Walker from Alabama, were told to get off the train. Due to a massive earthquake, it could not continue on to San Francisco as scheduled. Neither Minnie nor Rutherford knew each other before this trip. Davis, traveling from Paso Robles, California, where she had been attending secondary school, was able to contact the Methodist church community for temporary housing and a job. Walker was also traveling to San Francisco in search of work. (Courtesy of Monterey Historical Society, Inc.)

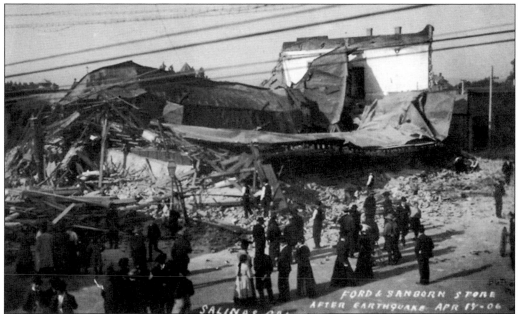

The aftershocks of the 1906 earthquake were felt throughout the Bay Area and Monterey County. This photograph shows damage to the Sanborn Store in Salinas, established at Ford and Sanford Streets. While at the train stop in Salinas, Minnie Davis and Rutherford Walker witnessed severe damage. Salinas became their final stop. (Courtesy of Monterey Historical Society, Inc.)

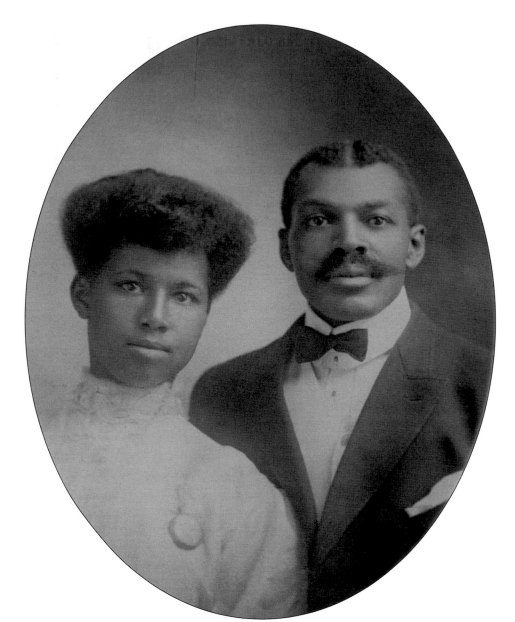

Told that the train would not travel on to San Francisco, gentleman Rutherford Hayes Walker carried Minnie Davis's bag from the depot to her destination. According to family, Minnie contacted the Methodist community in Pacific Grove and found work as a live-in nanny for a family on Thirteenth Street. Once Rutherford found work, he began courting Minnie, and they married on September 12, 1906, in Pacific Grove. Minnie, a cook at St. Angela Catholic Church rectory, once disguised herself as a boy in order to work on a Portuguese fishing vessel. In 1920, Rutherford established a bootblack stand in Carmel, on Ocean Avenue between San Carlos and Dolores Streets. Walker cleaned and polished the riding boots of patrons from nearby riding academies, earning 50¢ for a pair of boots. In 1941, the *Carmel Pine Cone* stated, "Rutherford Hayes Walker was the longest-established businessman in Carmel." Rutherford previously worked as a cook at the Presidio of Monterey. He died in 1947. Minnie and Rutherford Walker are seen here in their wedding photograph. (Courtesy of Marguerite McSween Fearn.)

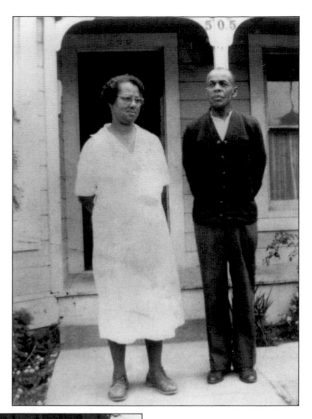

Within a short period of time, the Walkers were able to save money and buy a house on Ninth Street in Pacific Grove. Today, a part of the original house is still standing and is occupied by a family member. Minnie and Rutherford Walker (right) had eight children. In the below photograph, five of the eight children pose in front of the Ninth Street house. In the stroller is Leticia Walker, born on June 24, 1922. (Both, courtesy of Marguerite McSween Fearn.)

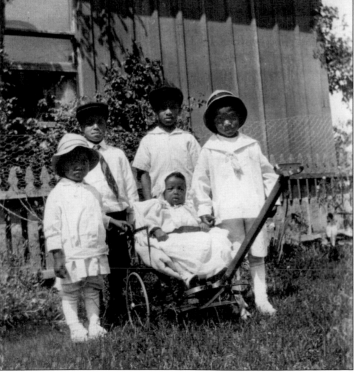

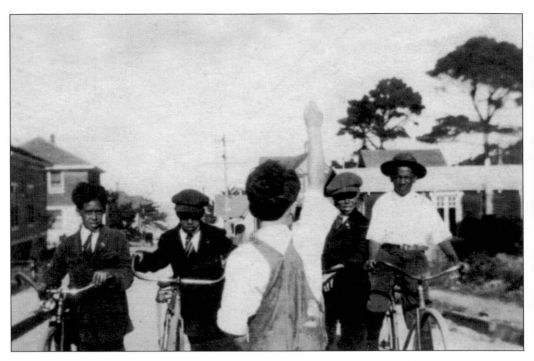

In the 1920s photograph above, four of the six the Walker brothers ride bikes on the streets in Pacific Grove. Shown below is Leticia Walker's second-grade class at Pacific Grove Grammar School in 1929. She is standing in the second row from the top, fifth child from the right. Many years later, Leticia's two children, Marguerite and Alton, also attended Pacific Grove Grammar School and Pacific Grove High School, as did Leticia Walker McSween. (Both, courtesy of Marguerite McSween Fearn.)

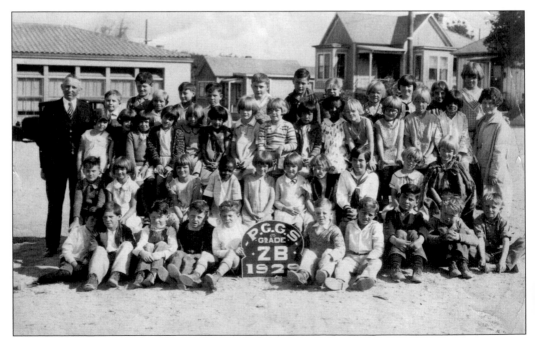

In 1946, Leticia Lee Walker married Alton McSween, a master sergeant from New York stationed at Fort Ord. Leticia and Alton met at the fort's black USO. The couple had two children, Marguerite McSween Fearn of Pacific Grove and Alton Maurice McSween of Los Angeles. Leticia and Alton were stationed in both the United States and Europe. Upon returning home, Leticia served for 30 years as a federal employee in the post supply division and, later, the finance and accounting office at Fort Ord. Below, Leticia and her daughter Marguerite are shown at Leticia's retirement ceremony. (Both, courtesy of Marguerite McSween Fearn.)

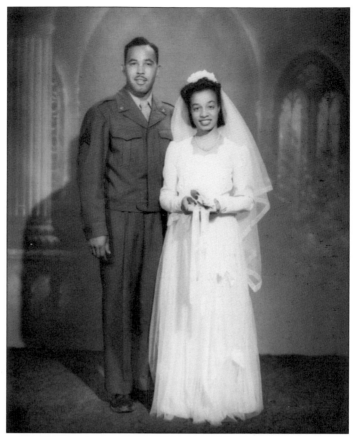

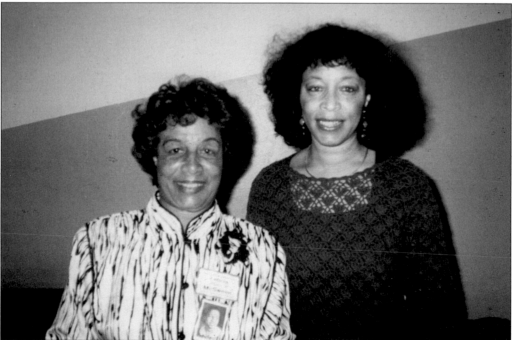

Born in 1900, Annabel Gatlin (pictured) was sent in 1908 from an orphanage in Kansas to Monterey to work as live-in help for Mrs. Gatlin, an African American who did laundry for local residents. In 1914, at 14 years old, Annabelle gave birth to son Lafayette. When, two years later, she gave birth to daughter Frances, Mrs. Gatlin told her that two children were too many for the home. Frances's father was a Danish sailor who did not settle in the area. Right after Frances's birth, Annabelle gave her up for adoption to George and Maime Smith, who lived near Annabelle at 1481 Hoffman Street in New Monterey. This allowed Frances to maintain contact with her birth mother and her brother, Lafayette. (Courtesy of the James and Socorro Green family.)

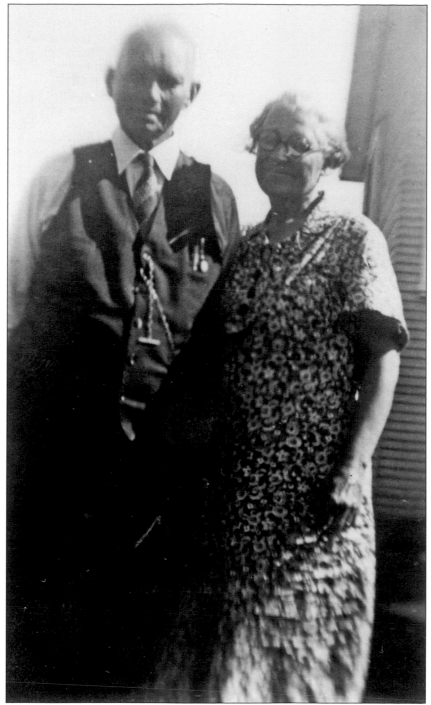

George Washington Smith and Maime Smith settled in Monterey in 1909 after George retired from the military as a master sergeant and invested in property. In 1916, they adopted Frances and raised her in what was called New Monterey. They owned several houses and rental properties in Monterey County. George and Maime were active members of First Baptist Church of Pacific Grove. George Smith was one of the founding members of the church. (Courtesy of Douglas Sutton.)

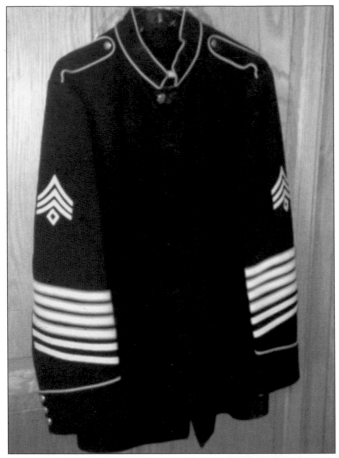

In 1898, George Smith fought with the 25th Infantry in Cuba and the Philippines. He was wounded going up San Juan Hill. In the below photograph, Smith is seated on the first row, fourth from the right. Shown at left is the military jacket worn by Smith in the group photograph. Smith met Cornell Allensworth in the Philippines during the Spanish-American War. According to grandson Douglas Sutton, both men climbed up San Juan Hill together. After the war, in 1909, Smith purchased 10 acres of land in Allensworth, an African American town near Bakersfield, California. (Both, courtesy of Douglas Sutton.)

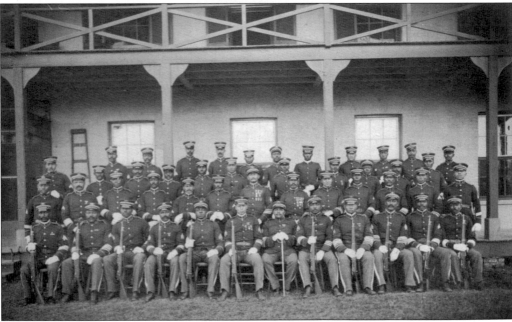

During the 1920s, Annabelle Gatlin married Moses Hunter, a prizefighter. Hunter is seen in the right photograph at 80 years old. The couple raised Lafayette (below), born in 1914, and he lived in Seaside until the 1990s. Lafayette worked as a mason and owned property throughout Seaside. According to Frances's son Douglas Sutton, Moses worked on the fishing boats in Monterey in the 1940s, and Annabelle was employed as a domestic worker. (Both, courtesy of Douglas Sutton.)

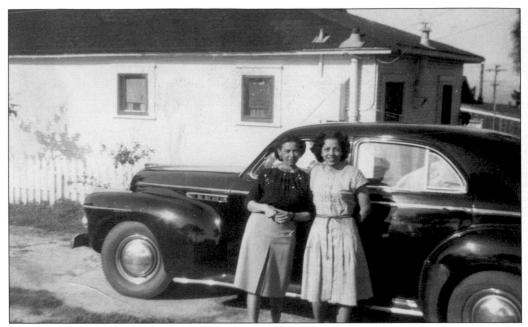

The Smiths provided well for Frances. In the above photograph, Frances (right), a teenager, stands next to her car with her friend Alyce Broussard of Salinas. The below photograph shows an African American women's social club. Members include, from left to right, Leticia Walker, Lucile ?, four unidentified servicemen's wives, Elizabeth Walker, unidentified, and Ethel Johnson. (Both, courtesy of Douglas Sutton.)

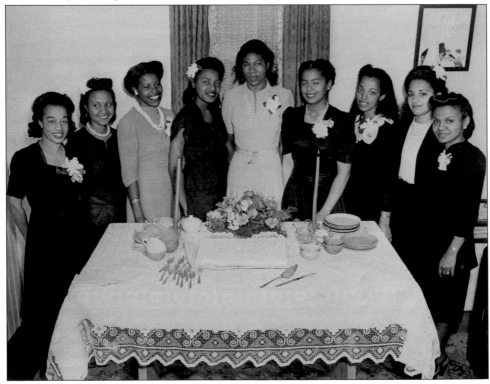

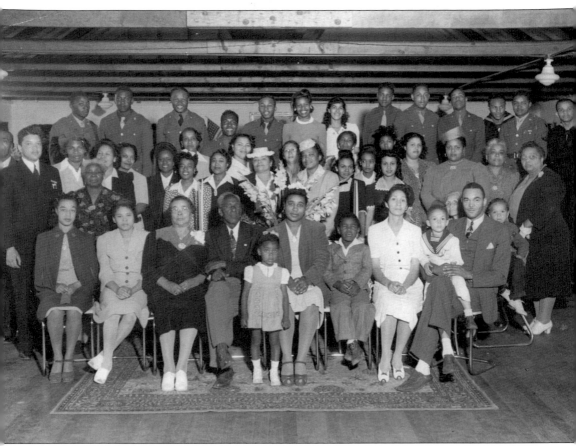

Since 1941, United Service Organizations (USO) served members of the US military. In 1942, the first USO for black servicemen opened, and in 1943, centers for black servicemen opened all over the country. USO centers integrated after President Truman integrated the military in 1948. In the photograph above, taken in 1944, servicemen, their wives, and community members attend a USO event. Maime and George Smith supported the USO for black soldiers on Delmonte Boulevard. Letty Walker is seated in the first row at far left, and eight-year-old Douglas Sutton and grandmother Maime Smith are in the second row at far right. Fern Anthony is in the third row, third from the right. Maime Smith served as a volunteer at the Monterey's USO for black soldiers. (Courtesy of Douglas Sutton.)

At left, Frances's son Douglas Sutton is shown with his grandparents George and Maime Smith in the 1930s. In the below photograph at Walter Cotton Middle School in 1950, Douglas is at far left in the first row. Other black students include Joyce McClish (second row at left) and Albert McKinney (fourth row, second from left). Douglas graduated from Monterey High School in 1954. After high school, he attended San Jose State University and eventually relocated to San Jose, California. He retired from Pacific Bell, having worked in information systems. His father, Samuel Sutton, was a merchant seaman and lived in Monterey until 1943. (Both, courtesy of Douglas Sutton.)

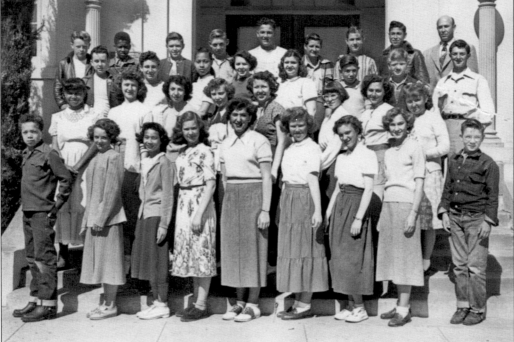

Shown here are Frances and Leroy Jolivet in 1999. In 1948, Frances married Leroy, from Louisiana, a soldier at Fort Ord. They met at the black USO. Frances was employed at a cleaner in Monterey. In 1945, Leroy retired from the military and worked as a mason in Monterey. In 1954, Leroy and Frances Jolivet moved to San Jose when Douglas left for college. Frances died in 2004 at 87 years old. Leroy Jolivet, now 92, lives in San Jose, California, near Frances's son Douglas. (Courtesy of Douglas Sutton.)

Estelle Guyton McElroy and Warren McElroy pose with a Ford Model T on Park Street in Monterey. Estelle was the daughter of William Henry Guyton from Alabama, who, in the early 1900s, migrated with his wife, Susie, to Pacific Grove from Texas in search of work and a home to raise children. They brought 12 children and William's mother-in-law, Susie, known as "Grandmother House." Their daughter Estelle gave birth to Mary Ellen Harris, who today, at 89 years old, remembers fondly the home at 315 Park Street where she and her cousins loved to play. The house became a site for the annual family reunion. Many of the sons and daughters of William and Susie Guyton worked on the peninsula as cooks, in the canneries, in the laundries, and in private homes as domestic workers. Mary Ellen Harris recalls her grandfather William Guyton at one point working as a cook at the Del Monte Hotel in Monterey. William Henry and his wife, Susie, died three months apart. The home on Park Street was sold and was demolished in the 1960s. (Courtesy of Mary Ellen Harris.)

After Mary Ellen was born in 1925 in Pacific Grove, her parents, Estelle and Warren McElroy, relocated to Los Angeles. After Warren's death, Estelle moved back to Pacific Grove to take care of her father, William Henry Guyton, in 1951 after her mother, Susie, died. In 1958, Mary Ellen moved back to Pacific Grove to take care of her mother. When Estelle passed away, Mary Ellen found work at the Silas B. Hayes US Army Hospital in administration. In 1972, she worked as a supervisor in the clerical and statistical departments. Mary Ellen's daughter, Michele, was born in 1945 and attended Pacific Grove Elementary School. She graduated from Monterey High School in 1962. Michele completed both bachelor's and master's degrees at UC-Berkeley in psychology and history and was employed at UC-Berkeley for many years. She has married and relocated to Hampton, Virginia. Mary Ellen has two grandchildren and three great-grandchildren. Mary Ellen is seen here with her daughter Michele Frances. (Courtesy of Mary Ellen Harris.)

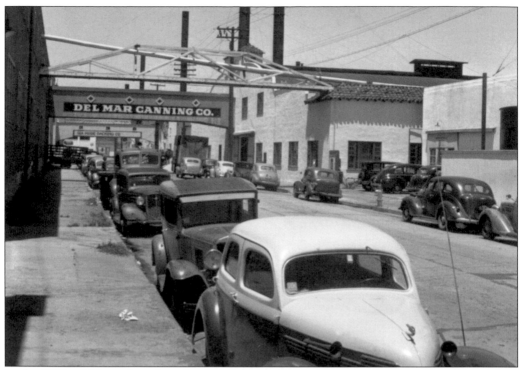

In the 1930s, African American families from the South and Midwest migrated to cities within Monterey County. Once in Monterey, many black families faced discrimination and found it difficult to purchase homes. African American residents of the peninsula today recall limited employment opportunities, settling as domestic workers in the homes of white families. Women found work in laundries and canneries. Men found jobs working in the fields, canneries, and, in a few cases, on shipping vessels; some worked as drivers for white families; others established shoeshine businesses. In spite of the practice of restrictive covenants, which limited the number of homes available to black home buyers, and segregation in the military before President Truman's desegregation orders, the cities of Monterey County represented a new beginning, especially for families leaving the harsh conditions of the Jim Crow South. The below photograph, taken in 1934, shows first-grade students at Bay School. Many parents of these students worked in the canneries. The above photograph, taken in 1945, shows Del Mar Cannery of Monterey. (Above, courtesy of Monterey Public Library, California History Room, George Robinson Collection; below, courtesy of Monterey Public Library and Japanese-American Citizens League.)

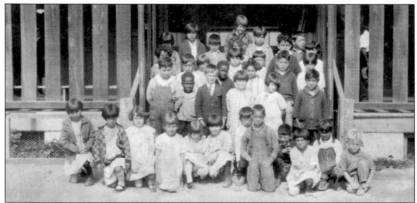

Geraldine Niblett, born in Texas on January 24, 1907, relocated to Pacific Grove with her husband, Johnnie Niblett Sr., and their nine children in 1937. They lived in a house on Junipero Avenue. Geraldine found employment as a domestic and also worked at the canneries. After arriving in the Monterey area, Geraldine and Johnnie separated. Geraldine bought land in Monterey County in the area known today as Seaside, and she started a restaurant business. In the late 1940s, the Fremont Inn, at Harcourt Avenue and Fremont Boulevard, was a well-known place for delicious hamburgers, says many of those who patronized Niblett's establishment. The restaurant, catering to soldiers away from home, offered home-style cooking. A few soldiers knew Niblett as "Mama Niblett." In addition to the restaurant, she owned a boardinghouse on Wanda Street in Seaside, which became home to many of Fort Ord's black soldiers. (Both, courtesy of Velma Evans.)

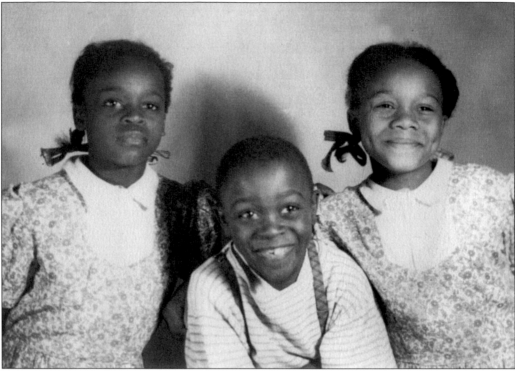

Shown above are the three youngest of Geraldine Niblett's nine children, Barbara Jean (left), Frank, and Velma. In the below photograph, Velma (right) and Barbara Jean pose with an unidentified soldier. (Both, courtesy of Velma Evans.)

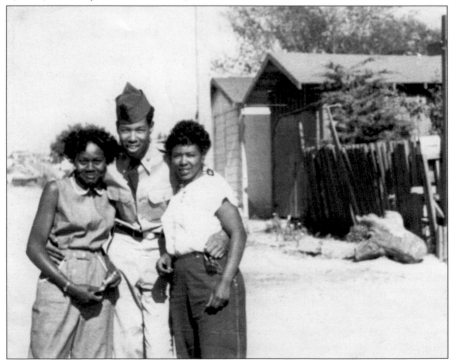

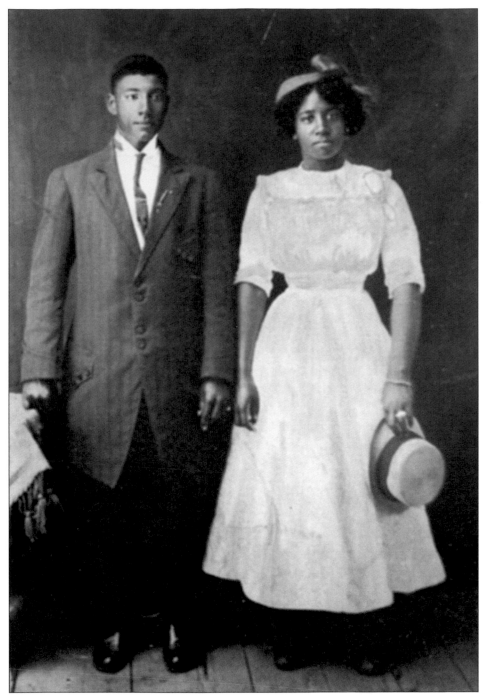

Agnes Tebo's parents, Joe Prada Dronet and Leontyne Louvia, are seen here in Louisiana before Agnes was born. Joe Prada Dronet migrated to Salinas in 1925 from Louisiana in search of work. According to Agnes and extended family members, Joe worked in the fields until he was able to establish a shoeshine stand near the stand of Louis Tebo on Main Street. Joe's stand was across the street from the Jeffery Hotel. He also managed and coached a local African American baseball team of the Negro leagues. Joe lived in the area until he died. (Courtesy of Audrey Boutte.)

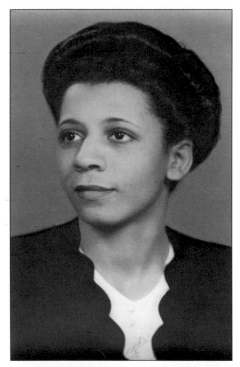

Agnes Dronet Tebo, seen at left in 1953, was born in October 1914. She supported her ailing mother and younger sister as a teenager by working in several low-skilled jobs. In 1937, she migrated to Salinas by train from Delcambre, Louisiana, in search of her father, Joe Praida Dronet, who relocated from Texas to Salinas. Agnes later met Louis "Bonnie" Tebo when visiting Texas, and in the 1940s, she encouraged Louis, her family members, and the Boutte and Broussard families from Louisiana to migrate from the South to Salinas. Though the family faced racism and discrimination, Agnes and Louis considered Salinas the "promised land." After settling there, Agnes worked as a caterer and seamstress before taking a job as a domestic for the Tynan family, for whom she worked for over 47 years. Because of segregation throughout the peninsula, in the 1950s, Agnes started the Culturettes Social Club, which provided social activities for members of African American communities. Seen below in the 1960s are, from left to right, Culturette Club members Agnes Tebo, Lydia Maines, Nan Sampson, Dula Broussard, and Ruby Buch. (Both, courtesy of Agnes Tebo.)

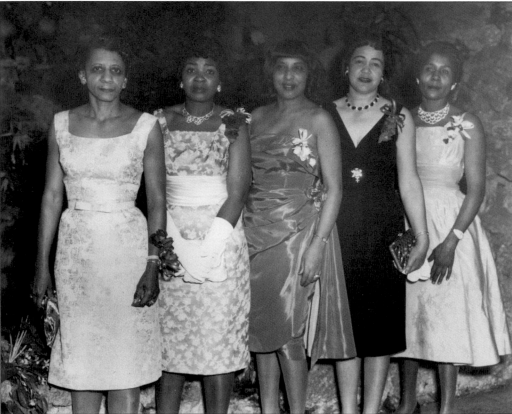

Louis "Bonnie" Tebo (right) migrated to Salinas from Texas to marry Agnes. They were married for over 50 years. The Tebos, along with William Greenwell, who had a shoeshine stand on Main Street in Salinas, started a NAACP branch in Salinas in 1939. Greenwell became its first president. A major challenge facing African American families who moved to Salinas was finding suitable housing. It took more than six years for the Tebos to buy a home due to the practice of restrictive covenants. Even Ignatius Cooper had problems moving back into the home he grew up in on Maple Street. Agnes and Louis Tebo helped many family members relocate by providing housing in their home or space for a trailer on their lot. This was a common practice. Both Louis Tebo and Joe Pradia established shoeshine businesses on Main Street. Louis operated his stand in front of the Jeffery Hotel, on the corner of Main and Alisal Streets, in the 1940s. The Jeffery Hotel was opened in 1888 by James A. Jeffery; it operated until March 1, 1968. (Right, courtesy of Agnes Tebo; below, courtesy of the Monterey Historical Society, Inc.)

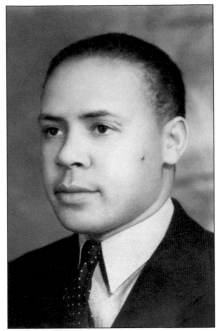

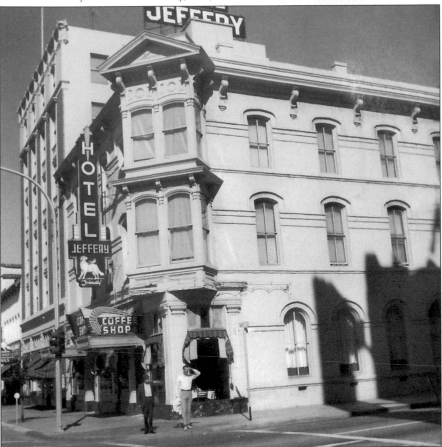

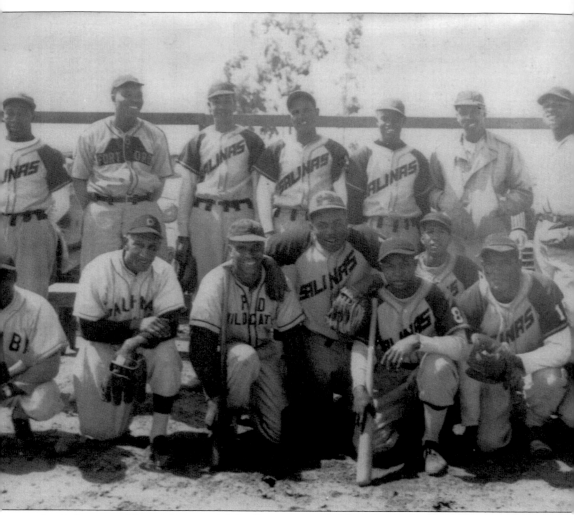

Louis, known as "Bonnie," along with Joe Boutte, started a Negro baseball team, the Golden Dragons. The Golden Dragons played in the Salinas Valley League in the 1940s and often played against traveling Negro league teams. Shown here are, from left to right, (first row) John Anderson, Joe Prada, unidentified, "Crip," E.Z. "Smitty" Smith (brother-in-law to Agnes), unidentified, Wellington Smith, and unidentified; (second row) three unidentified players, Joseph Boutte, Eli Ross, and two unidentified players. (Courtesy of the Wellington Juvenile Hall of Monterey County.)

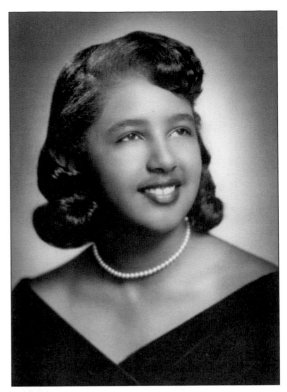

Seen here in their Salinas High School photographs are Agnes's cousins Ethel Boutte (right) and Audrey Boutte (below). (Both, courtesy of Agnes Tebo.)

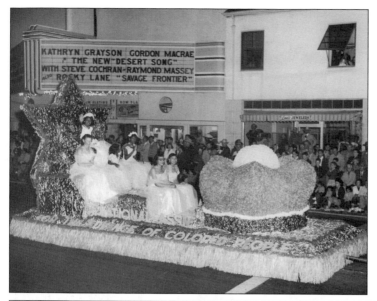

Ethel, Audrey, and friends ride in the Salinas NAACP float in 1951. Shown here are, from left to right, Maxine Brussard, Ethel Boutte (on throne), Doris Ramsey, Audrey Boutte, and two unidentified girls. (Courtesy of the Monterey Historical Society, Inc.)

At top in this family photograph are Agnes Tebo (right) and her sister Roseanna Boutte. Seated at left is Ethel Boutte, and next to her is Audrey Boutte. Agnes was instrumental in bringing the Boutte families to Salinas in the 1940s. The family members have always admired and honored her. Today, Salinas continues to honor Agnes for her many years of volunteerism. (Courtesy of Agnes Tebo.)

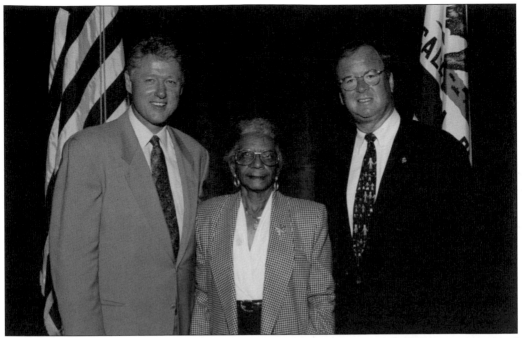

In this photograph, taken in early 2001, Agnes Tebo receives an award for her many years of volunteerism. She is standing with Pres. Bill Clinton (left) and Sen. Sam Farr. (Courtesy of Agnes Tebo.)

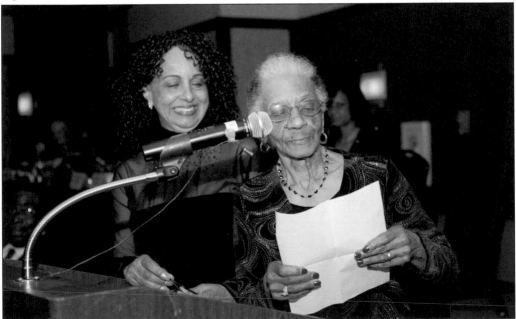

On February 27, 2010, Agnes Tebo received the NAACP's President's Award for her work as a community advocate. It was presented to Agnes by Ben Jealous, president of the national NAACP. Tebo, a charter and life member, was also presented with resolutions by mayors of Monterey County cities. Today, Agnes, 99, still loves to discuss community problems and solutions for issues facing residents of Salinas. (Courtesy of Agnes Tebo.)

Shown is the Monterey Cemetery gravesite of William H. Smith. Smith, who served in the 1st Squadron, 9th Cavalry from 1902 to 1904 above China Point with his brother Louis Smith, died in 1930. Before William H. Smith's death, Louis and William owned and operated the Smith Taxi Service in Monterey from 1910 to 1928. Below are the parents, William P. Smith and wife Mary Elizabeth. William P. Smith was born in slavery in 1838 and at 16 ran away to join the Union army. In 1929, William P. Smith moved to Monterey with Wellington Smith Sr., Wellington's wife, Evelyn Smith, and four children to join Louis and William Smith. Wellington and his father, William H. Smith, purchased a family home at 1200 Prescott Street in Monterey for Wellington's family and to raise William's children after his death. Wellington Smith Sr.'s children all attend Monterey High School and excelled in sports. (Left, courtesy of Leah Washington; below, courtesy of Reginald Smith.)

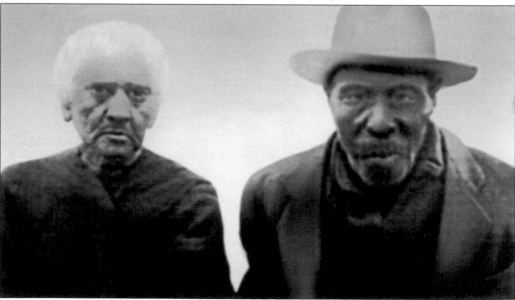

# *Three*

# THE ESTABLISHMENT OF AFRICAN AMERICAN CHURCHES

In 1907, African Americans from throughout the Monterey Peninsula began to meet informally in Pacific Grove in a temporary location until a formal church was established. Today, over 21 African American churches exist in Monterey County, providing leadership for the community. These churches include First Baptist, Friendship Baptist, Community Missionary Baptist, Bethel Missionary Baptist, Ocean View Baptist, New Hope Baptist, St. James CME (pictured), Hays CME, Greater Victory Temple COGIC, Emanuel COGIC, Royal Family COGIC, Christian Memorial COGIC, and Mount Nebo Baptist Churches. (Courtesy of St. James CME.)

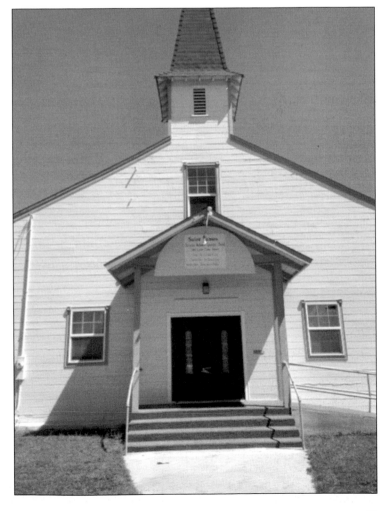

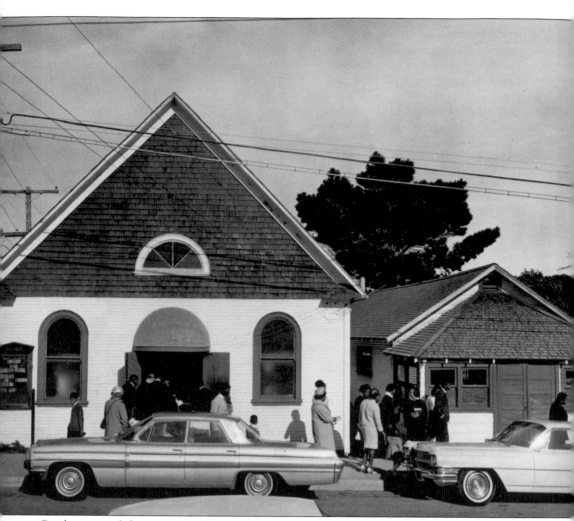

By the turn of the century, the migration of African American families to Monterey coastal communities and the Salinas Valley resulted in the establishment of the first black church, and in 1909, First Baptist Church of Pacific Grove was birthed. It was the first African American establishment on the peninsula and is the mother church for many African American congregations. Prior to the establishment of First Baptist Church, Reverend Lewis from San Jose came to El-Bethel Mission, located at the corner of Fountain and Light House Avenues. He conducted church services for the black residents of Monterey, as stated in the *Daily Review* newspaper on July 1, 1909. As a result of Lewis's efforts, organizing for First Baptist Church began. In a church report, "sixty colored residents" from the Monterey Peninsula had identified themselves as members of the church at this time. Shown here is the original building of First Baptist Church of Pacific Grove. It was demolished in 1965. The new church was built at this same location. (Courtesy of First Baptist Church.)

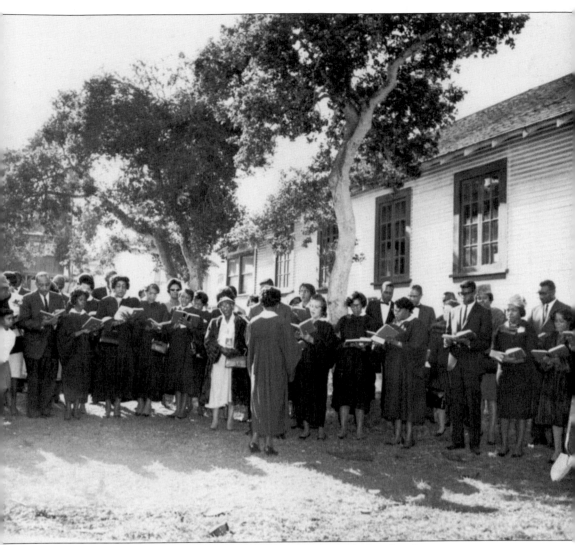

The early ministers of First Baptist Church often came from surrounding bay-area communities or as far as Spokane, Washington. First came Reverend Lewis of San Jose, then Rev. Emmett Reed of Spokane, who established Calvary Baptist Church of Spokane, and Rev. J.L. Allen of Oakland, who later established Allen Temple in Oakland. These ministers served for only a short period until First Baptist of Pacific Grove hired a Methodist, Rev. Wellington Smith Sr., to pastor the church. He did so from 1930 until the early 1940s. Historically, African American churches not only addressed the spiritual needs of their members but have also served African American members in the surrounding communities, meeting their physical, political, educational, and social needs. Here, a choir sings at the ground-breaking ceremony for the new First Baptist Church in the 1960s. (Courtesy of First Baptist Church.)

According to church history, the first congregation of the African American community was established in 1909. Today, over 21 African American churches exist in Monterey County. Many of the black churches recognize First Baptist of Pacific Grove as their mother church. In the black community, the purpose of the church is not only to provide spiritual development but also to meet the social, political, and educational needs of its members and the broader community. The below photograph shows the ground-breaking ceremony for a new addition to First Baptist Church in 1966. Rev. Richard Nance Jr., who served from 1956 to 1992, is holding the shovel. Deacon Robert Rogers, Jr. is standing to the left of Nance. At left, the Nance family is seen in the 1950s. (Both, courtesy of First Baptist Church.)

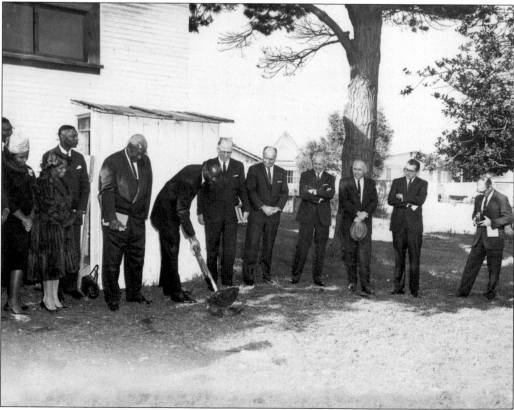

In 1945, Mother Dora Isom, 75, moved to Monterey County in the area known today as Seaside. After arriving on the peninsula, she joined First Baptist Church of Pacific Grove. She worked as a midwife to pregnant women throughout the peninsula until she reached 90 years old. She began practicing midwifery first in Mississippi and then in Oklahoma before moving to Monterey. In a 1960 newspaper article, she stated that she believed she had delivered over 7,000 babies since she began midwifery at the age of 18. A devout Christian woman, Isom says she has never missed a service, prayer meeting, or club meeting at Pacific Grove's First Baptist Church. (Courtesy of Walter Jones and family.)

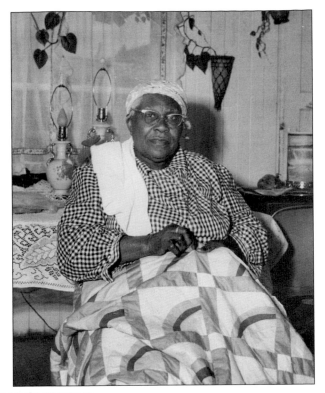

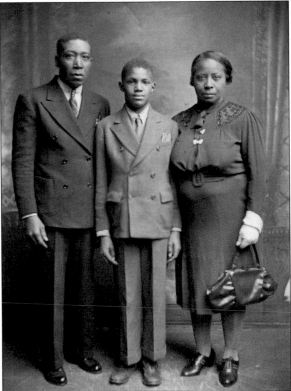

In this photograph, Deacon Walter Jones stands between his aunt and uncle, with whom he lived in San Francisco before moving to Monterey with his grandmother, Mother Dora Isom of First Baptist Church. Jones attended Monterey High School in the 1950s. Later, he served as deacon under Bishop S.R. Martin. Jones continues to serve as a deacon for Greater Victory Temple Church in Seaside. (Courtesy of Walter Jones and family.)

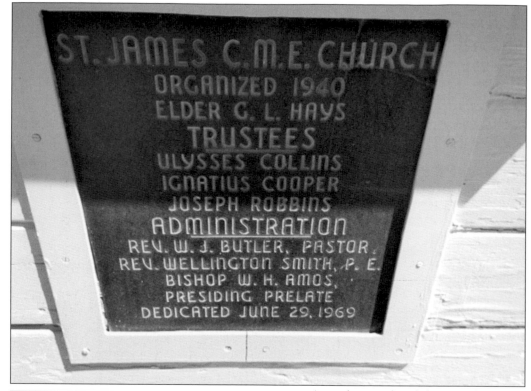

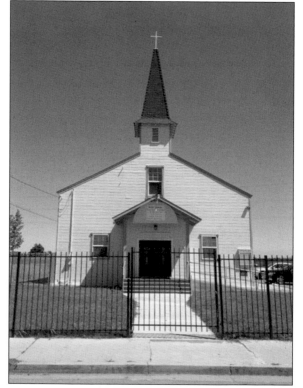

According to church history, the African American families of Salinas began seeking to establish a church in the 1940s. Ignatius Cooper, Agnes and Louis Tebo, Joe Prada, and others began the effort of establishing a local church. The first pastor was Rev. Leroy Johnson from Fort Ord, who began holding church meetings in homes of organizers until the first location, a storefront at 213 Market Street, was acquired. In 1939, the land at the site of the present-day church was purchased in the name of St. James Colored Methodist Church. The church, an army chapel, was purchased by the early organizers in Salinas from the War Asset Administration in 1947 and moved to the land on Calle Cebu. (Both, courtesy of St. James CME.)

Rev. Wellington Smith Sr. (right) was the first appointed pastor of St. James CME in 1940. Reverend Smith also served as the president of the NAACP of Pacific Grove from 1931 to 1946. Smith moved to Monterey from Texas with his wife, children, and father, William P. Smith, in 1929. He also served as the pastor of the First Baptist Church of Pacific Grove from 1930 to 1940. In 1940, Reverend Smith helped the families of Salinas organize St. James Colored Methodist Episcopal Church. The founding members of the church are the Smith, Cooper, and Robbins families. In the below photograph are Reverend Smith and his wife, Evelyn Smith. (Right, courtesy of St. James CME; below, courtesy of Reginald Smith.)

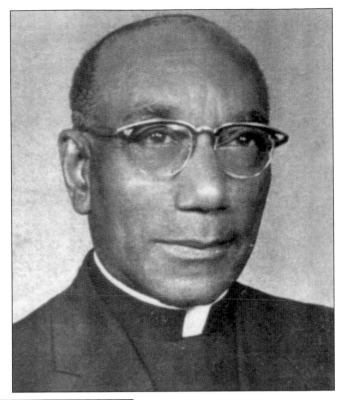

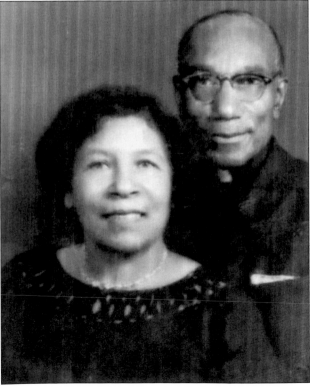

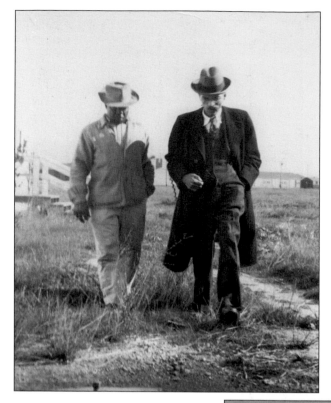

In this 1947 photograph, Brother Greer (left) and Elder G.L. Hays walk the land purchased at Calle Cebu. They are discussing plans to move the military chapel to this site. (Courtesy of St. James CME.)

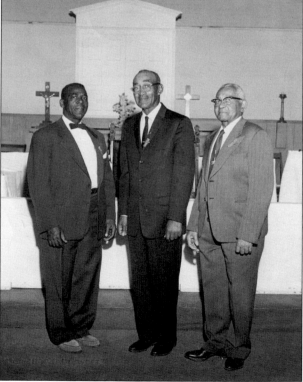

Shown here are the early church stewards of the St. James Colored Methodist Episcopal Church in Salinas, Ulysses Collins (left), Ignatius Cooper (center), and Joseph Robbins. (Courtesy of St. James CME.)

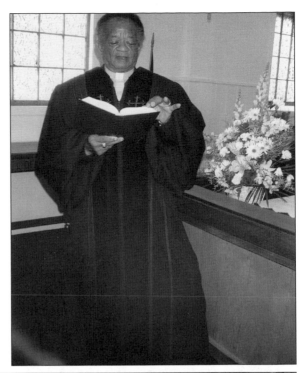

Rev. Fred Holt (right) and Rev. Annie Cruse (below) are responsible for the new pews installed in the church in 2005–2006. The previous pews were the original structures when the building served as an Army chapel. Reverend Cruse donated her salary to purchase new pews. Reverend Holt also served as the president of Salinas's NAACP. (Both, courtesy of St. James CME.)

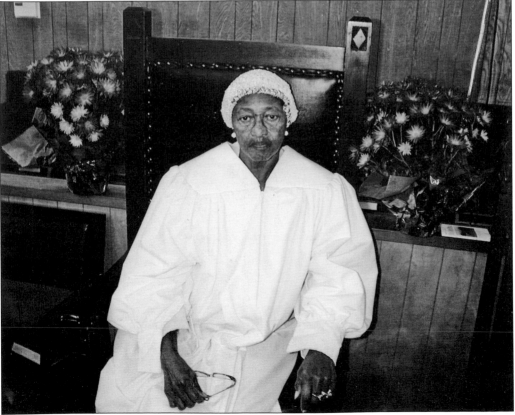

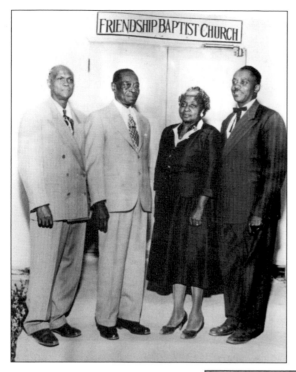

Friendship Missionary Baptist Church was established on July 2, 1945, at the Old Fire House in Oak Grove, Monterey. The first pastor, Rev. W.W. Wells, stands at left in the photograph at left. The original organizers and officers are, from left to right, Wells, Deacon William Neblett, Sister R.M. Brazier, and Brother Ira Beverly. Beverly served as president of the men's department in 1952. Other organizers not in the photograph are Sister Sarah Sexton, Rev. F.W. Wells, Sister Frances Long, and Sister Sarah Bell. The below photograph shows Mother Frances Long, who sold the lot on Seventh Street and Broadway Avenue in Seaside in August 1945 for $450 to build Friendship's first church. The congregation remained in this building until 1954. In November 1947, Rev W.L. Harris was called to pastor this tiny church. (Both, courtesy of Friendship Baptist Church.)

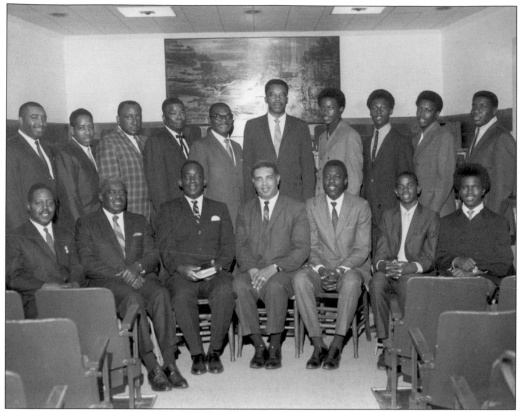

One of the most influential pastors was Rev. Lewis McFadden, who served in that position for 30 years, from May 16, 1956, to 1986. In this photograph, Reverend McFadden is sitting at center in the first row. Under McFadden's leadership, the lots on Seventh Street and Broadway Avenue and on Judson Street and Broadway were sold, and the church purchased the present-day location at 1440 Broadway. The mortgage was burned in 1964. The original church structure was expanded, and the congregation grew. In 1967, the church was able to purchase a new parsonage. (Courtesy of Friendship Baptist Church.)

Reverend McFadden stands at left next to Dr. Martin Luther King Jr. in the early 1960s, when King visited the churches of Seaside. Standing on the far left is Rev. Ellis Pastor of Ocean View Baptist Church. King and McFadden were good friends. (Courtesy of Friendship Baptist Church.)

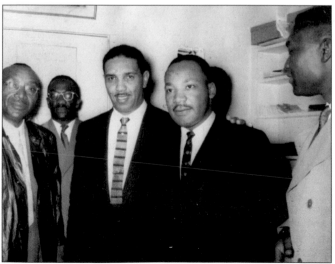

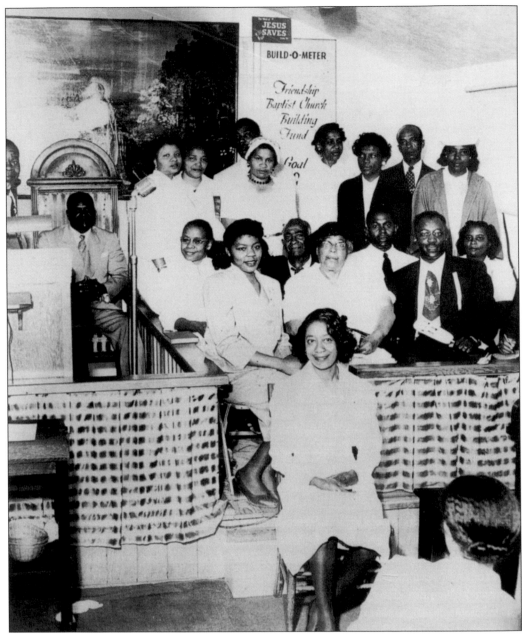

To many of its parishioners, Friendship Missionary Baptist Church lived up to its name. It was known as the friendliest church in Seaside. Rev. I. Walter Holt became pastor in August 1954. Through his leadership, the church on Seventh Street and Broadway Avenue was moved to Broadway and Judson Streets. Under the direction of Reverend Holt, a bus system was developed to provide transportation to the military men and women who wanted to attend services but had to return to base shortly after 12:15 p.m. on Sundays. Since 1945, Friendship Missionary Baptist Church has been engaged in missionary work in the United States, Liberia, Palestine, Iran, and Asia. Specifically, the church has participated in shipping clothes to programs for children on Indian reservations and for migrant farm families. This photograph shows the early members of the church. (Courtesy of Friendship Baptist Church.)

Elder S. Rudolph Martin (right) and his wife, Primrose (below), and sons S. Rudolph and Daniel Martin, moved to the Monterey Peninsula in the summer of 1943 after Elder Martin had a dream about starting a church in Monterey. Martin felt God led him to Monterey. His father-in-law, Bishop E.E. Hamilton of San Francisco, ordained him. The first church meetings were held at Elder Martin's home. On September 5, 1943, services were held in a storefront at 215 Franklin Street in Monterey under Martin's leadership. After the storefront on Franklin Street, the membership moved to a second storefront on Del Monte Avenue. In 1976, Bishop Martin led the congregation through the task of building a new church on Broadway Avenue and Yosemite Street. Before completing this project, the Lord called Bishop S.R. Martin home. The membership completed the church in his memory. (Photographs by Camera Masters, both courtesy of Daniel Martin.)

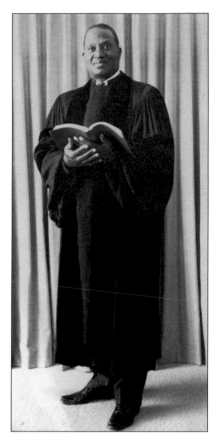

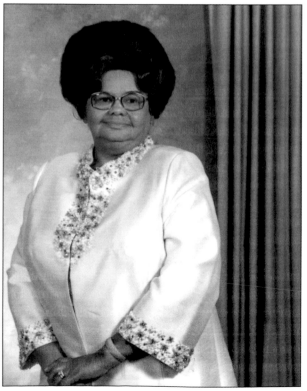

Elder Martin and his wife, Primrose (left), migrated from Texas to Wyoming in 1938–1939 before relocating to California to join Primrose's father and mother, the E.E. Hamilton family, in San Francisco in 1942. As stated in the book *On the Move*, by S.R. Martin Jr., the Martin family headed west during World War II, along with other African Americans. The Martins believed that California was "near to heaven on earth." Like many African American families, they did not expect racial segregation and Jim Crow, as found in Texas. The below photograph shows the first church, on Harcourt Avenue. In 1945, the congregation began purchasing land on Harcourt Avenue. One condition of sale in Monterey County's official deed form stated the property could not be leased to or occupied by any person of the Ethiopian race. (Both, courtesy of S.R. Martin Jr.)

Pictured at right are the sons of S.R. Martin and Primrose, Rudy (left) and Dan. They are standing next to a car in Seaside, California, in 1949 or 1950. During these early years of the church, Dan Martin recalls the church sponsored community-wide barbecues that followed Reverend Martin and Deacon B.M. Neil's many hunting trips. Below are Daniel (left) and Rudy Jr. as boys in the 1940s. (Both, courtesy of S.R. Martin Jr. and Dan Martin.)

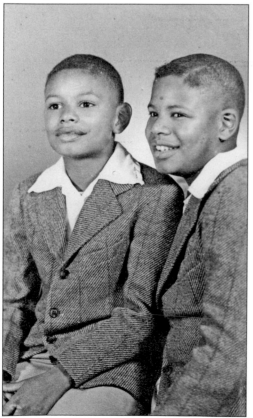

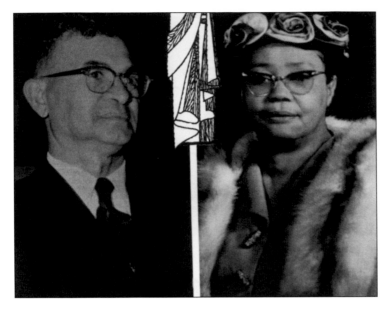

Rev. E.E. and Bessie Hamilton, the parents of Primrose Hamilton Martin, migrated to San Francisco in 1941. As pastor of Greater Emanuel Church of God in Christ, San Francisco, E.E. Hamilton licensed S.R. Martin. When Reverend Hamilton became bishop, he often visited the Seaside church, Victory Temple. (Courtesy of S.R. Martin Jr.)

Greater Victory Temple Church of God in Christ was completed in 1983. Here, members march from the old church on Harcourt Avenue and Freemont Boulevard to the new church on Broadway Avenue and Yosemite Street, singing praises all the way. They are led by Pastor Wilber Wyatt Hamilton (center, in robe), son of Bishop E.E. Hamilton. Sister Primrose Martin, the queen mother of Greater Victory Temple, cut the ribbon. (Courtesy of Dan Martin.)

# *Four*

# ON THE WINDS OF WAR, NEW LEADERSHIP, AND NEW OPPORTUNITIES

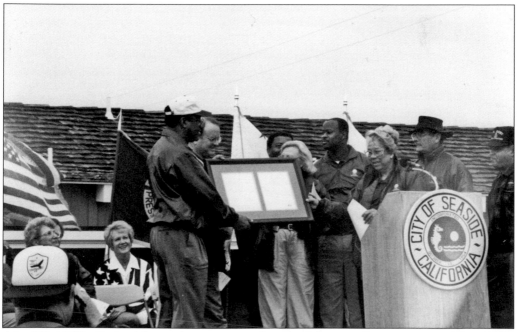

After World War II, the African American population in Monterey County increased from 2,721 in 1950 to 7,917 in 1960. By 1980, the black population increased to 18,825, and by 1990, it reached 22,849. With the increasing African American population came new opportunities and leadership in business, education, public service, and social and political life. When Fort Ord closed in 1994, the black population began to decline, to 15,050 in 2000 and 11,300 in 2010, or three percent of the population in Monterey County. In this photograph, Mayor Don Jordan (left) and council members are receiving two golf courses from the military. (Courtesy of Don Jordan.)

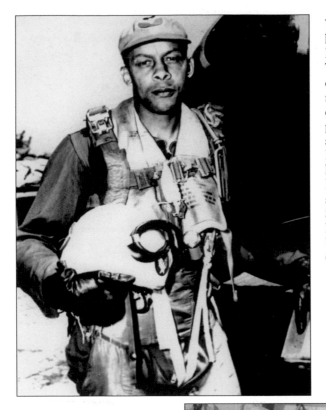

William Ayers Campbell, seen here in 1941, joined Tuskegee Institute's 99th Fighter Squadron. The squadron's wingmen led pilots of the 33rd Fighter Group. The moniker "Wild Bill" was stenciled on the fuselage of Campbell's plane, indicating his persistence and courage. During World War II, Colonel Campbell is known to have downed two enemy planes. By the end of the war, he served as commander of the 99th Pursuit Squadron, becoming one of the highest-ranking black officers in the US Army Air Force. (Courtesy of the Campbell family collection.)

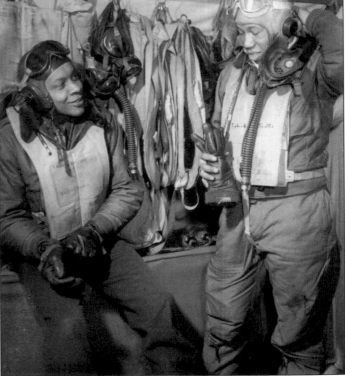

Preparing for a mission in Italy in March 1945 are Capt. William Campbell (left) and Lt. Thurston Gaines. Lieutenant Gaines left the military after World War II and has had a distinguished medical career. (Courtesy of the Campbell family collection.)

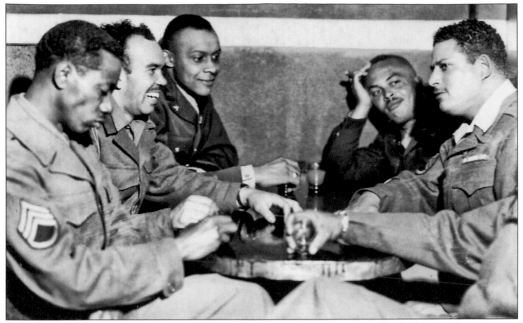

Seen in the below photograph are the commander and officers of the 99th Pursuit Squadron in Italy in 1944. Lt. William Campbell is seated on the right side in the rear. In front of Campbell is Benjamin Oliver Davis Jr., commander of the 99th. Across from Campbell is Airman Spanky Roberts, and on the left side is a noncommissioned officer. The photograph above shows Campbell, Davis, and others at a local bar in Italy in 1944. Benjamin O. Davis Jr. was the first African American general in the US Air Force. General Davis commanded the 332nd Fighter Group, called the "Red Tails." (Both, courtesy of the Alfred Glover collection.)

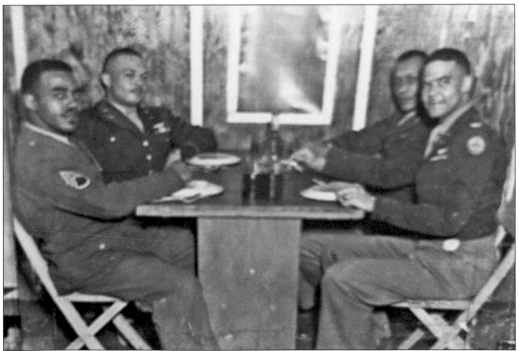

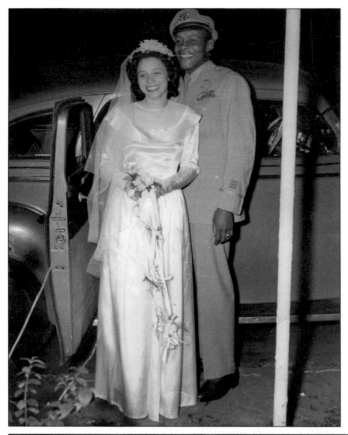

The left photograph shows William Ayers Campbell and Wilma Jean Burton Campbell on their wedding day in 1946. Below, the Campbell family poses in 1959 on their way to Turkey. Wilma is holding baby David. Standing in front of William are Stephen (second from right) and Bill Campbell Jr. (Both, courtesy of the Campbell family collection.)

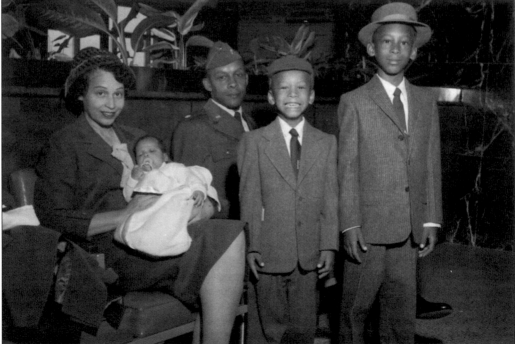

William Campbell was awarded several Distinguished Flying Cross Awards. By the end of World War II, the 99th had never lost a bomber it was escorting to enemy fire. After the war, Campbell was assigned to Tokyo, and in 1953, as a lieutenant colonel, he served in the Korean conflict as the wing inspector and combat squadron commander, leading an all-white group of jet pilots, until 1955. With America in another war, in 1963, Campbell, then a colonel, served in Vietnam as director of operations, Air Force section of the military advisory team, until 1967. At the end of a distinguished 40-year career, in 1983, Colonel Campbell continued to serve, accepting a professorship at the Naval Post Graduate School in Monterey. At this time, he relocated his family to Seaside. (Courtesy of the Campbell family collection.)

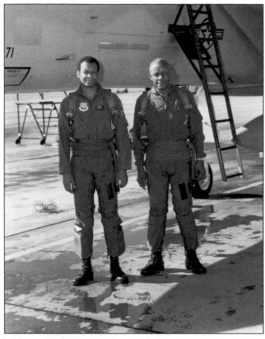

Bill Campbell stands next to his son pilot Stephen Campbell after a flight in a F-15 at Luke Air Force Base in 1986. During the one-hour flight, Stephen flew one airplane, and Bill flew with Stephen's squadron commander in another. (Courtesy of the Campbell family collection.)

The Campbell family poses for a photograph in 2006. Stephen (far left) is a pilot with Southwest Airlines. David (center) is the athletic director at UC–Santa Barbara. Bill (far right) is a judicial officer for the US Postal Service. Standing in front are William Ayers Campbell and Wilma Campbell. William passed away in 2006. (Courtesy of the Campbell family collection.)

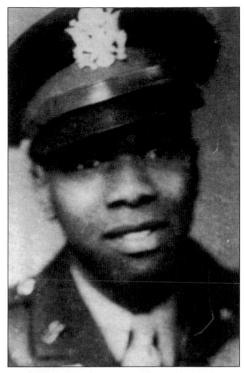

Maj. Sherman William Smith Sr. (right), a Tuskegee Airman, joined the military in 1942 in Oklahoma and served in the Air Force division of the Army during World War II and the Korean War. Major Smith, a spotter or "forward observer" pilot for fighter planes, earned two Purple Hearts for his service. He was transferred to Fort Ord in 1959. Shown below is the 1940 airman communication class. Sherman Smith is standing in the second row, fourth from left. (Both, courtesy of the Smith family.)

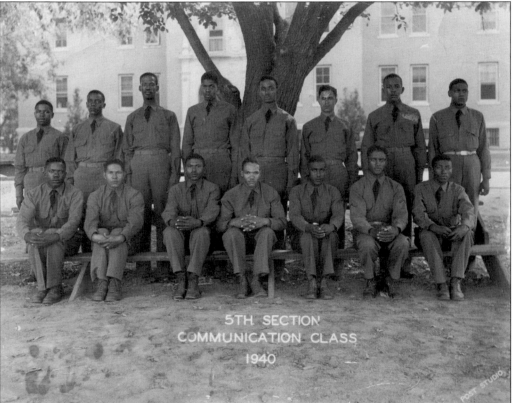

5TH SECTION
COMMUNICATION CLASS
1940

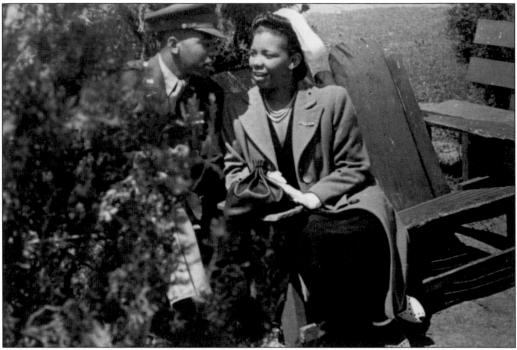

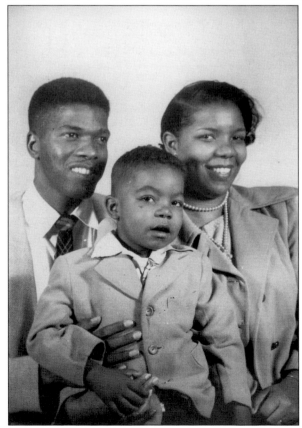

Maj. Sherman Smith and his wife, Elizabeth, were married for 68 years. They started dating in the 1940s. The left photograph, taken in 1950, shows Major Smith and Elizabeth with Sherman Jr. When the family moved to Seaside in 1959, Sherman Smith served as the first black Army helicopter pilot at Fort Ord; he also worked as an Army air traffic controller. After retirement, Major Smith was elected to the Seaside City Council and served as Monterey County NAACP president. Major Smith and Elizabeth encouraged family members to relocate to Seaside, and he often stepped in as a father figure to his nieces and nephews. His family remembers him as a man who walked the talk: "He had no room for nonsense;" "He was straightforward, light-hearted, and humorous, and you could depend on him." Major Sherman, born May 1920 in San Antonio, Texas, died peacefully on January 12, 2010. Elizabeth continues her volunteer work with the Links, Inc. (Both, courtesy of the Smith family.)

Seen here are the Purple Heart and the Tuskegee Airmen patch worn by Maj. Sherman Smith. (Courtesy of the Smith family.)

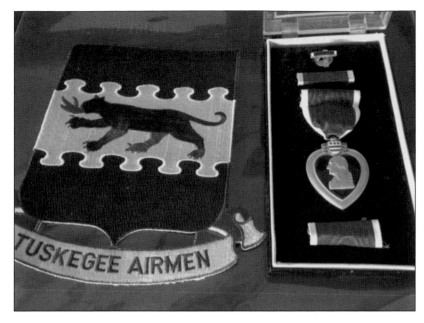

This photograph was taken at a Monterey Peninsula College Board awards ceremony in 2009. Sherman Smith, seated here with wife Elizabeth, received an award for his service on the Monterey Peninsula College Board of Trustees for over 32 years. Smith, 90, poses here with his grandson Vincent Smith (left) and nephew John Smith (far right). (Courtesy of the Smith family.)

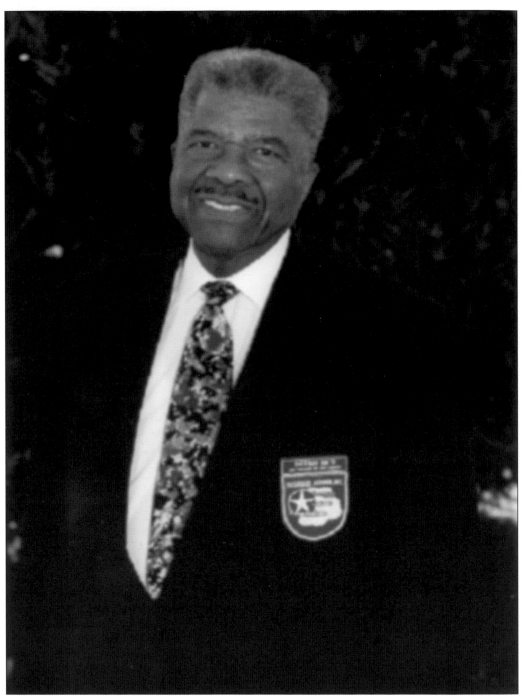

After retiring from the military in 1960, Maj. Sherman Smith decided to make Seaside his home, and he began serving the community. Sherman and Elizabeth integrated the neighborhood in Ord Terrace by buying a home, despite a restriction limiting the sale of property to African Americans and other minorities. (Courtesy of the Smith family.)

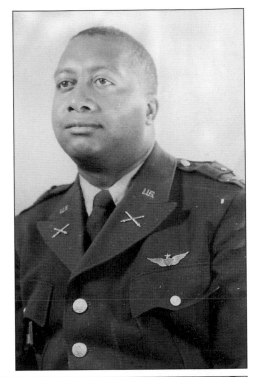

Maj. Charles Harris Drummond was born in Boston in 1922 and died in Monterey in 2000. An airman, Drummond did not fly missions in World War II. He was in a tank division and then joined the Air Corps in 1945. In the late 1950s, Drummond was assigned to the Defense Language Institute to study German. By 1968, Major Drummond (at right and below at right) served as a helicopter squadron commander in Vietnam, where he served two tours of duty and was wounded. In 1968, he was the first African American commanding officer at Fritzsche Army Air Field at Fort Ord. In 1965, the family moved to Seaside from Germany. The following year, the Drummonds moved to Monterey, near Monterey High School. (Both, courtesy of the Drummond family.)

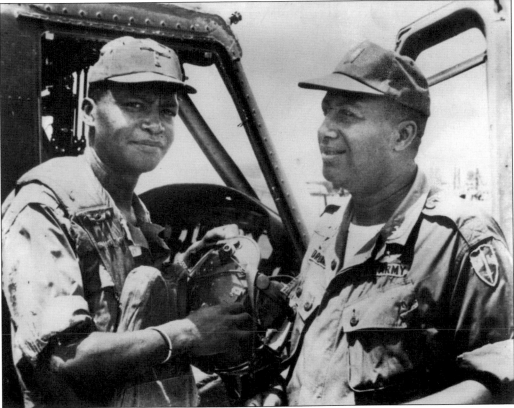

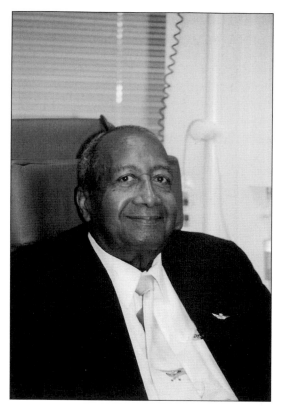

Charles and Doris Drummond met while in college, and they later married. In college, Doris was a member of the AKA Sorority in 1944. In the early 1970s, Doris decided to enroll in San Jose State University, and she earned her bachelor of arts in education. With additional coursework at the Monterey Institute of International Studies, she began teaching in the middle schools in the Monterey Unified School District. (Both, courtesy of the Drummond family.)

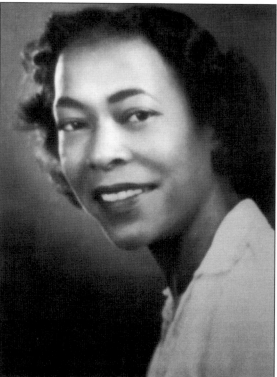

Charles Drummond's Poor Scholar Bookstore, located on Alvarado Street in Monterey, operated from 1968 to 1972. Charles Drummond's business had two other locations: in the lobby of the San Carlos Hotel and in the lobby of the La Playa Hotel in Carmel. Drummond was also the owner of Harris Management Co. from 1972 to 1982, Allstate Janitorial Services, the Phoenix Company, and Drummond Services, specializing in process serving, from 1985 to 1997. (Courtesy of the Drummond family.)

In 1993–1994, Charles Drummond started a summer youth flight academy for at-risk children. The Drummond family believes that Charles was always a man ahead of his time. The photograph depicts the Drummond family in 1979. From left to right are (first row) Jean and Mary Ann; (second row) Raymond Charles, David Carl, Carl Edward, and Charles Harris III. The Drummond children attend schools in Monterey and are success stories in their own lives. (Courtesy of the Drummond family.)

Seaside was fortunate to have many outstanding military heroes. This photograph, taken in the 1980s, shows Gwen Lassiter, principal of King Junior High, with the remaining buffalo soldiers and Tuskegee Airmen. Shown here are, from left to right, George Williams and E. Walker James, members of the Citizen's League for Progress; buffalo soldiers Frank Steele and T.R. Gaines; Lassiter; and Tuskegee Airmen Sherman Smith, William Campbell, and Charles Drummond. (Courtesy of the Monterey Peninsula NAACP.)

Alfred P. Glover, on the right, came to Fort Ord in Seaside with his family in 1970 from Virginia, 22 years after the desegregation of the military by Harry Truman. Glover described many of the African American commissioned officers assigned to Fort Ord as well educated, some from historically black colleges. Some were graduates of officer candidate school, and others were commissioned on the battlefield from the Korean War or graduated from West Point. Even with integration, black officers faced resistance when commanding white troops. In order for integration to work, both white and black officers had to work together. Colonel Glover commanded the 2nd and 3rd Training Battalions. Al Glover and his wife, Parniest Glover (below), met while attending South Carolina State College. He graduated in 1953, and the couple married in 1954. The Glovers consider Seaside an excellent place to raise children. (Both, courtesy of Alfred Glover.)

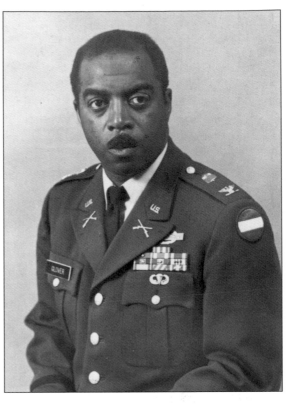

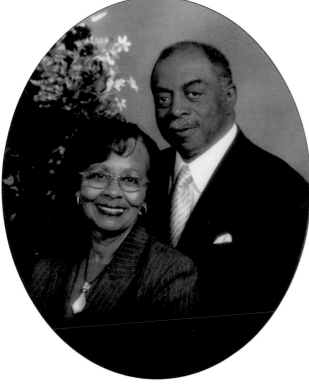

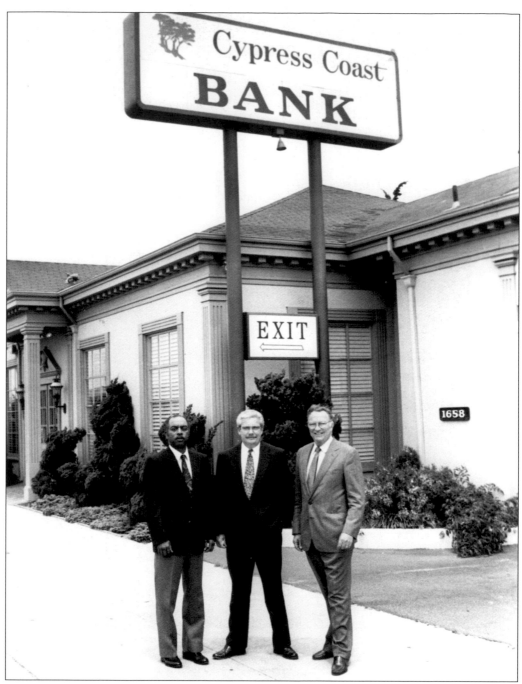

Al Glover (left) had always wanted to build an apartment building in Virginia, so after his military career, in 1975, Glover build a five-unit complex in Seaside on Harcourt Street. Glover erected his second five-unit building five years later. Since then, Glover has continued building throughout the Monterey Peninsula. A residential and commercial developer, Alfred P. Glover has been the chief executive officer of Glover Enterprises since 1980. Today, Glover is one of the founders of Cypress Bank in Seaside. Al Glover is seen here with other founders of the bank, including Fred Rowden (right). (Courtesy of Alfred Glover.)

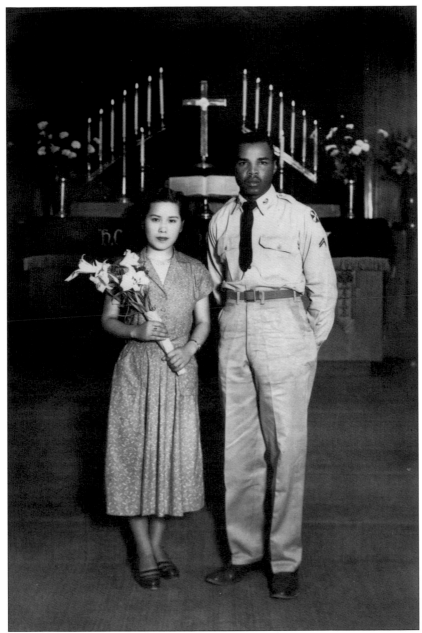

Many military soldiers who married Asian or German wives were often sent to Fort Ord because of laws against interracial marriages in many Southern states. John Banks Jr., who served in the military from 1941 to 1952, moved to Monterey in 1952 with his wife, Joanna (Ichiaji Tanaka Kuwatani), whom he met in Japan and married during World War II. For this family, settling in Monterey County was challenging, as they had to deal with the issues of the restrictive conveyance practices. John Banks overcame the problem of finding housing in Pacific Grove by buying land and then building a house of his choice. This family faced double discrimination because of their mixed black and Japanese heritage in a town where, many years earlier, Pacific Grove's Chinese fishing village was burned to the ground, and many Japanese citizens from the Monterey Peninsula and Salinas Valley were sent to internment camps. (Courtesy of George Banks.)

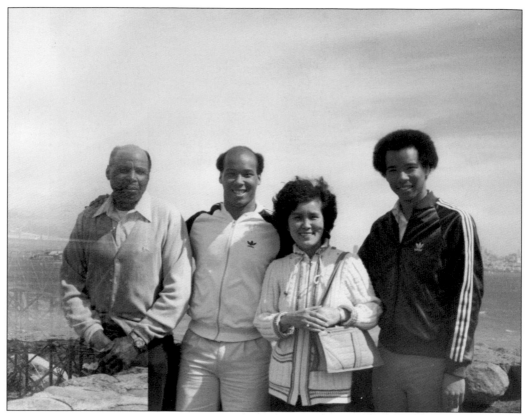

The Banks family enjoys a vacation above. Shown are, from left to right, John Banks Jr., Leroy, Joanne, and George Banks. John Banks Jr. became a prominent masonry architect for McEldowney & Sons, where he worked for 48 years before he died in 2000. Joanna passed away in 2014. Both sons, Leroy and George, attended school in Pacific Grove. The below photograph shows John and Joanne Banks. George Banks can remember his father saying, "Education was the key to success, especially for the Negro." (Both, courtesy of George Banks.)

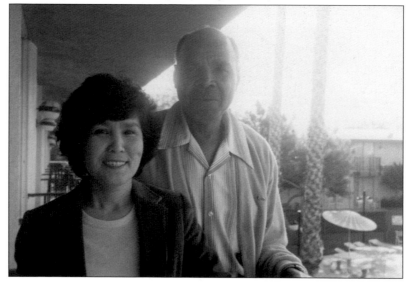

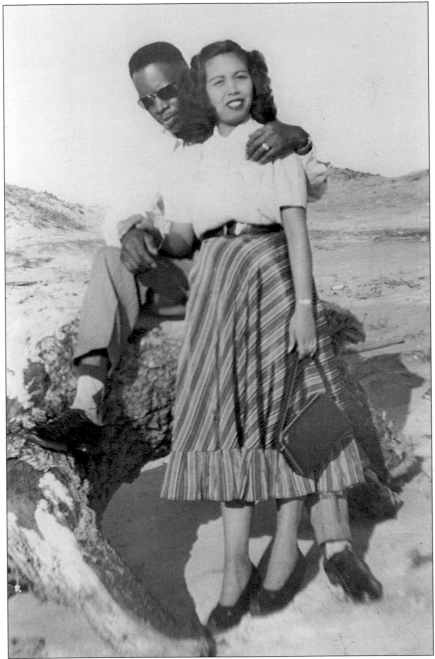

Pfc. James Green met his wife, Socorro, in the Philippines in during World War II, when Green served in the Army as the driver of a Duplex Universal Karrier, Wheeled (DUKW). He drove the DUKW in the Philippines and in Japanese waters. The DUKW was a 1942 amphibious vehicle used to move men, weapons, and equipment across the high seas. Green's company was on its way to Japan when they were diverted just before the first atomic bomb was dropped on Hiroshima. After his military discharge in San Francisco, Maj. James Green moved to Monterey, joining Army friends who at the time were living in Monterey. Moving to Monterey was the beginning of family life for Major Green and Socorro. (Courtesy of the James and Socorro Green family.)

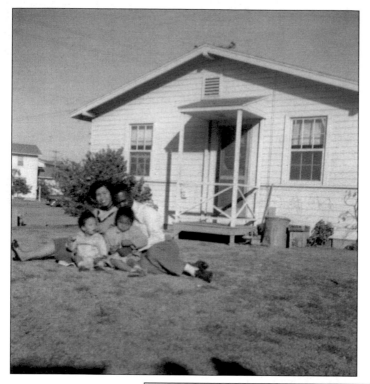

In Monterey, James and Socorro Green rented a home at 660 Fillmore Street (left) from Cliff Hooper, a black man who owned property in Monterey and rented to black servicemen. Major Green found a job working as a cook. Annabel Hunter was able to assist Green in obtaining a job as a cook at Blums at the Blue Bird Inn in Carmel. Eventually, Green became a sous chef at the Park Lane Senior Living Facility and Asilomar Beach Conference and Resort in Pacific Grove. Socorro was employed as a housekeeper for the Carlos Hotel and, later, the Townhouse Lodge. (Both, courtesy of James and Socorro Green family.)

Many throughout Monterey respected businessman and developer Homer Span. He moved to Monterey in the 1930s. A real estate investor, Span began purchasing land in the county. It is believed that he owned most of the residential and undeveloped land in Monterey County's unincorporated area of Seaside. Many who remember Homer Span refer to him as a "multimillionaire." He also had political ambitions, at one time running for the city council during Seaside's early years of incorporation. Span (right) is seen here shaking hands with other civic leaders. (Courtesy of Leah Washington.)

Adine Williams, a Seaside businessperson, was one of the first well-known African American women photographers. She began her career in 1936, while in high school, at the Wiltz Photography Studio in New Orleans. Williams was hired to retouch photographs as an apprentice under the direction of the owner, Mr. Wiltz. She was given Wiltz's old equipment, and, with her husband, Eddie H. Williams Jr., opened the Mclain Studio in New Orleans. In 1956, Adine and Eddie moved to Seaside and established Camera Masters in Monterey, on Broadway Avenue near San Lucas Street. A second studio was started on Santa Barbara Street, next to the main post office. Adine and Eddie Williams provided photography services at many black social events throughout Monterey County. Later, Adine became a minister at the Church of Religious Science on Broadway Avenue. (Both, courtesy of Leah Washington.)

After completing barber college in San Francisco, Leslie and Gladys McKinney (right) arrived in Monterey County in early 1954 to work as barbers at Fort Ord. Gladys attended a land auction with businessman Jack Simon. With the last of Leslie and Gladys's savings, she purchased 11 lots. After selling several lots, in 1955, the McKinneys built a barbecue and barber establishment on one of the lots on Broadway Avenue. In 1965, the McKinneys build a home on four of the original 11 lots. The below photograph shows Gladys and Leslie McKinney (right) and Leola and Albert Joyce. (Both, courtesy of Barbara Joyce.)

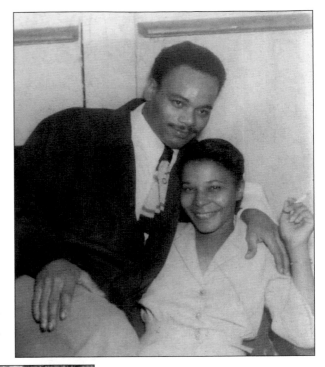

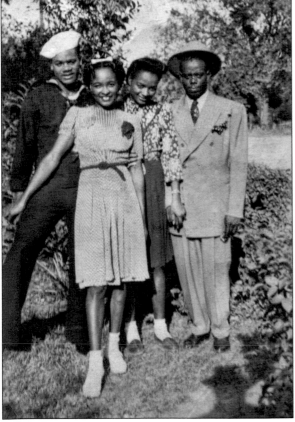

McKinneys' barbecue restaurant and barbershop were housed in the same building, with a door between them, allowing customers to eat lunch while waiting for a haircut. Gladys, a very talented barber, cut the hair of many servicemen as well as residents of Seaside. Leslie loved to cook, and people came from miles away to eat at his establishment. Both businesses were very successful. The McKinneys opened other restaurants around the peninsula. Many entertainers and artist from the Monterey Jazz Festival patronized the restaurant and became regular customers. It was a landmark until the McKinneys retired in 1986. (Both, courtesy of Barbara Joyce.)

Richard Joyce (right) was the son of legendary bandmaster Benjamin Leo and Zenobia Jewel Joyce of Austin, Texas. Richard moved to Monterey County in the 1950s at the advice of his sister Gladys Joyce McKinney. In Seaside, Richard worked as a custodian with the Monterey School District. Later, he was employed for 25 years with the City of Seaside's Redevelopment Agency as a building inspector, a position he held until he retired. Richard Joyce was instrumental in the planning and development of Seaside's incorporation, and he assisted in the establishment of the Seaside and Del Monte Heights Project. Richard Joyce, born on March 15, 1924, passed away on September 11, 2011, in Seaside. In the right photograph, Richard stands next to his grandson, Lamont Joyce. (Both, courtesy of Lamont Joyce.)

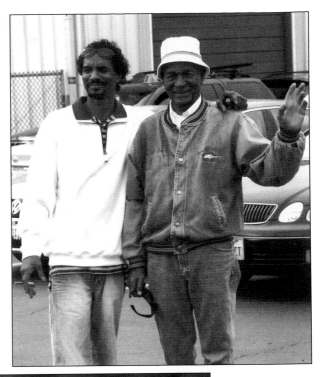

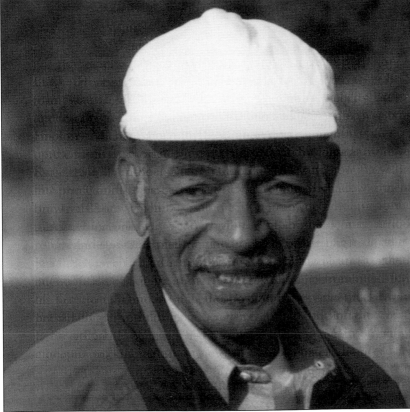

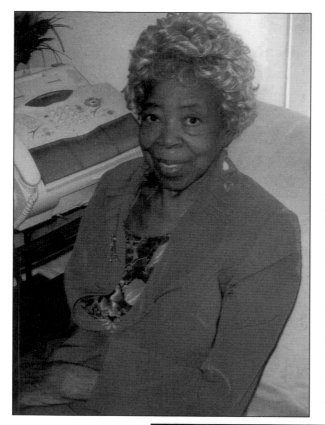

In the 1950s, Ira Lively relocated to Seaside, where she met and married James T. Lively Sr. In 1956, Ira Lively became the first female African American and only female police officer when she joined the Seaside Police Department, where she worked for 26 years. In 1968, Ira became the juvenile officer for the community of Seaside. As an officer, Ira taught at the Gavilan College Police Academy in Gilroy, California. She also served as the first African American female on the Monterey Peninsula Unified School District Board (MPUSD) in 1979. In 1984, she was elected to the Seaside City Council. (Both, courtesy of Illona Cooper.)

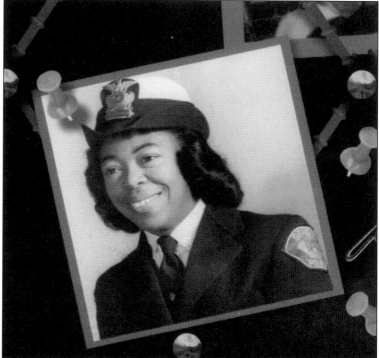

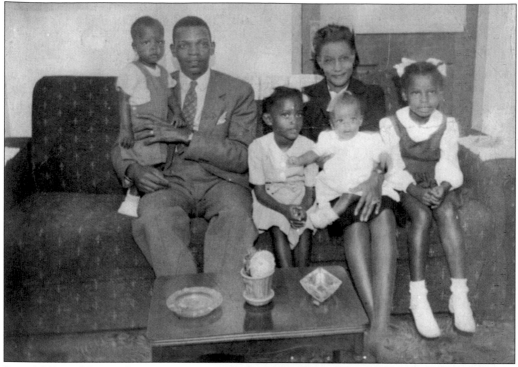

Pope McDonald moved to Monterey from Texas in 1948 to become the first black employee at the Naval Post Graduate School of Monterey. After retiring from the school in 1977 after 27 years of employment, McDonald traveled the world collecting black history memorabilia. For many years, he served on the Seaside Historical Commission. After retirement, McDonald traveled throughout California, presenting his black history memorabilia collection and lecturing to churches and organizations. The McDonald family had just moved to Monterey in 1945 when the above photograph was taken. The children are, from left to right, Leo (held by Pope), Vergia, Ronald (on Minnie's lap), and Marty. Pope and Minnie are shown at right at their 25th wedding anniversary celebration, held at the San Carlos Hotel in 1960. (Both, courtesy of Marty Myzack.)

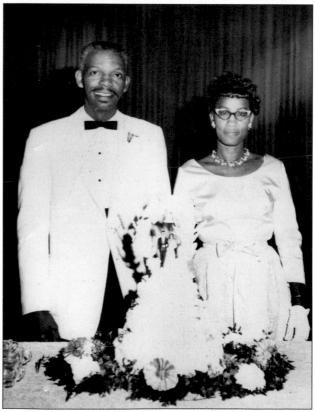

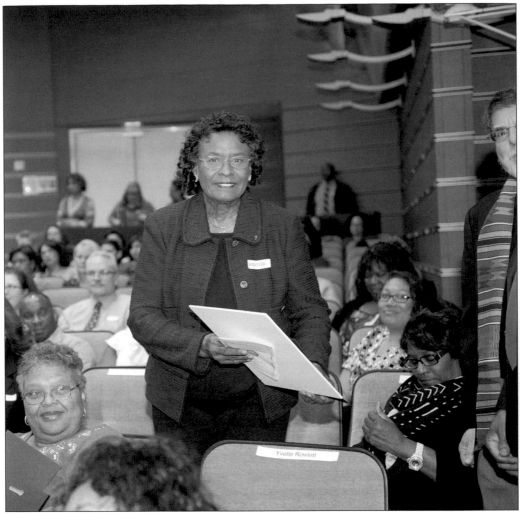

After earning a teaching degree from Albany State University in 1953, Dr. Charlie Knight moved to the Monterey Peninsula in 1955 with her husband, Sgt. Maj. Leroy Knight. Because MPUSD did not hire black teachers, Dr. Knight went to work in the laundry facility on Fort Ord. In 1963, the doors opened, and Dr. Knight received a teaching assignment at Highland Elementary School. In 1965, she was promoted to a counseling position, responsible for securing federal and state funds and fundraising. By 1965, hiring black teachers became a district priority, so Knight was assigned to recruit black teachers from the East Coast and the South. After tirelessly recruiting over 50 black educators for MPUSD, in 1979, Wilson Riles, former state superintendent of public instruction, recruited Dr. Knight to join his staff as the first black female associate superintendent of public instruction. Since retiring from a 42-year career in education, Knight continues her many community-wide projects. She has established the Knight Scholarship Foundation to continue the effort of improving the quality of education for black kids. (Courtesy of Leah Washington.)

A grade-school teacher for 45 years and a lover of music, Mrs. Willie McCoin (far right) incorporated music into her classroom lessons before retiring in 2004. She has sung in choirs since 1957 with Monterey Peninsula Civic Chorus and The Voices, under the direction Dr. Sean Boulware. Willie's son Gary R. Williams (center), a kindergarten teacher in Pacific Grove, incorporates music into his lesson plans to reach kids like his mom. (Courtesy of Willie McCoin.)

Billy F. DeBerry, recruited by Dr. Charlie Knight, began teaching mathematics and social studies in the Monterey Unified School District in 1968 at Martin Luther King Junior High School. Within a year, DeBerry became assistant principal, then principal, of Martin Luther King Junior High School. After serving as director of personnel and assistant superintendent of personnel, he was hired as the superintendent, serving from 1994 to 2000. DeBerry retired from the district in 2000 and has continued serving the communities of Monterey County through volunteer organizations, specifically, the Community Partnership for Youth (CYP). (Courtesy of Billy F. DeBerry.)

Mae Johnson came to Monterey in 1955 with her husband, who was assigned to Fort Ord. In 1962, Johnson began working as a substitute teacher before she was hired as a full-time teacher two years later. She found it difficult to purchase a home in Monterey because of the discriminatory housing practices that existed in the county. She eventually bought a house in Monterey, where she raised five sons. As an educator, Johnson is credited with creating a volunteer summer writing program for students at Martin Luther King Junior High School, which provides summer writing classes. Eventually, Mae Johnson became a counselor and then assistant principal before becoming principal. She retired from MPUSD in 1993 as the principal of Monterey High School. Johnson is credited with turning MLK around and has received many awards, such as the Milken Family Foundation Educators Award in 1987. (Both, courtesy of Mae Johnson.)

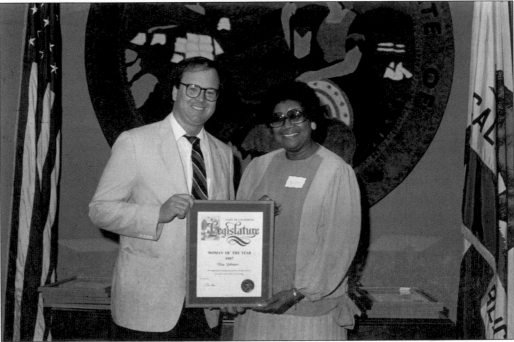

Born in Texas in 1922, Mattye Effie McNeal moved to the Monterey Peninsula in 1949 and married Robert Blakeney, who died four years later. Matteye worked as a teacher in MPUSD for 14 years. She had served as a civil rights activist and as an activist in the Poor People's Campaign. She promoted the beliefs of Martin Luther King in her classroom, and she is credited with providing thanksgiving dinner for needy families for over 13 years. She lived in Seaside for 47 years and died in 1996, but her efforts to serve the poor are continued today by her two daughters, Bobbie and Helen. They continue to provide Thanksgiving to families. Mattye Blakeney received numerous awards. One of the most distinguished is the Congressional Award as the founder of a childcare center and for her tireless work in education on the peninsula. She was presented with the award by Congressman Leon E. Panetta. (Both, courtesy of Bobbie Blakeney.)

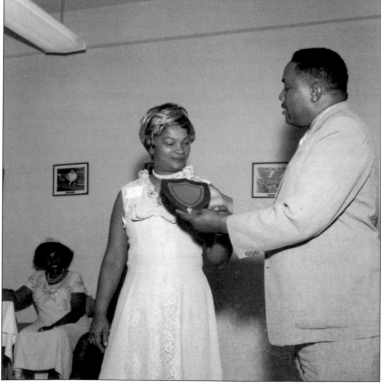

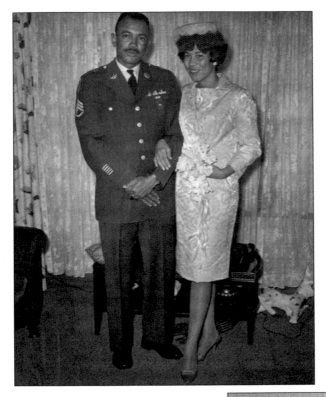

Helen Rucker came to the bay area from Louisiana in 1959 with a bachelor's degree in education and library science in order to pursue a doctorate at UC-Berkeley. Her first job in California was as a librarian for the Oakland School District at Lowell Junior High School. In 1964, Helen married James Rucker (left), an Army sergeant stationed at Fort Ord. They then moved to Seaside. Helen served as a librarian in Seaside schools and taught until she retired in 1988. In 1992, she ran for Seaside City Council, serving until 1998. She served as mayor pro tem from 1994 to 1998. In 2005, Helen was elected to the Monterey Peninsula Unified School District Board of Trustees, and she served until the spring of 2014. Below, the Ruckers are seen at home with son James. (Both, courtesy of Helen Rucker.)

Helen Rucker's volunteer activities are numerous. She is a lifetime member of the NAACP and serves on the Leon Panetta Task Force and the California State University–Monterey Bay Service Learning Advisory Committee. But, to Helen, her most important task is serving the community since 1999. She personally supports and staffs an office available for community meetings located on Fremont Avenue. She can be found promoting voter registration and community education programs as well as posting employment notices. In the below photograph, Helen (left) poses with longtime friend Mary Ellen Harris at her community office after a state and local primary election. The wall poster behind Helen and Mary Ellen was researched and constructed by student Natalie Labo. Above, Helen is seated with longtime friend Leon Panetta. (Both, courtesy of Helen Rucker.)

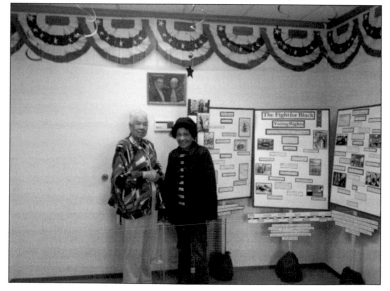

Oscar O. Lawson (left) was stationed at Fort Ord and served in the military for 26 years as a US Army artillery captain. After retirement, he was elected as the first African American mayor of Seaside (1976–1978). Prior to becoming mayor, Lawson served on the city council in 1974 and as mayor pro tem. As a city councilman and mayor of Seaside, Lawson worked to address housing and discrimination issues. He worked to reduce crime and helped to improve the quality of the community and city services. Lawson worked tirelessly at the state level for the passage of the 26th Amendment, allowing 18-year-olds to vote. Below, Mayor Lawson (left) attends a political event for Ted Kennedy (center). (Both, courtesy of Oscar Lawson family.)

Stephen Ross, seen here standing on the far left with Mayor Oscar Lawson (second from right), was elected to the Seaside City Council. Ross served as mayor for 16 years. The City of Seaside named the park adjacent to city hall and the library in Stephen Ross's honor. Like Lawson, Ross was a member of the NAACP and served in several leadership positions in Monterey. (Courtesy of the Lawson family.)

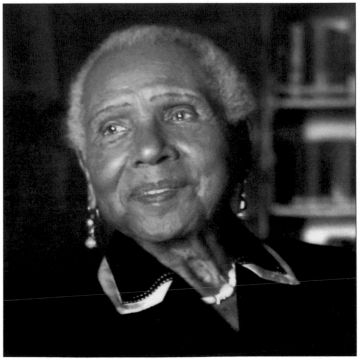

Seaside resident Pearl Carey, who came to Monterey with her military husband, became the first African American woman elected to the city council in the 1970s. An avid golfer, she was remembered as a woman ahead of her time. Considered the epitome of courage, Carey received numerous awards for her service to the communities of Monterey. In 1997, she founded the Seaside Junior Golf Program. (Courtesy of Alfred Glover.)

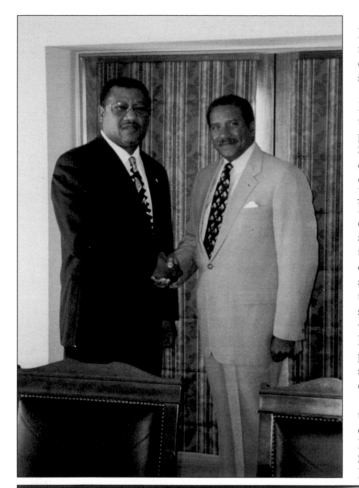

Maj. Don R. Jordan, a military retiree from Fort Ord, was elected to the city council and served as mayor in 1991, from 1994 to 1996, and from 2004 to 2008. Under his administration, the city focused on providing programs for the youth of Seaside, determining the reuse of Fort Ord, and building economic development. Under Jordan's administration, the Embassy Suites Hotel was completed. Mayor Jordan was also instrumental in securing the city's acquisition of two championship golf courses, along with additional land to build a resort hotel and several new homes. Jordan was a member of the Fort Ord Reuse Authority. In the left photograph, Mayor Jordan (left) shakes hands with Secretary of the Army Togo West in 1996. Secretary West presented the title of two Fort Ord golf courses, Bayonet and Black Horse, to Mayor Jordan and Seaside. (Both, courtesy of Don Jordan.)

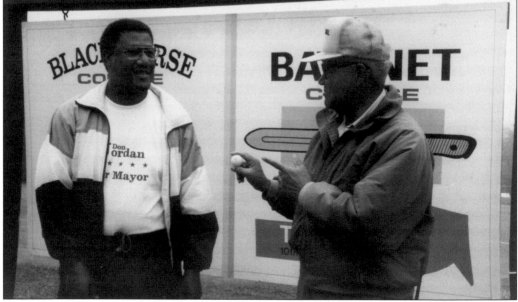

Alice Davis Jordan, wife of Don Jordan, also serves the communities of Monterey County. She is president of the Pan-Hellenic Council and the Kiwanis Club of Seaside. Like her husband, Alice tirelessly serves the community of Seaside. She is the organizer of the Martin Luther King Jr. Day program. Don and Alice Jordan pose in the right photograph. Below, Alice (standing second from right) is seen with women community leaders. (Both, courtesy of Alice Jordan.)

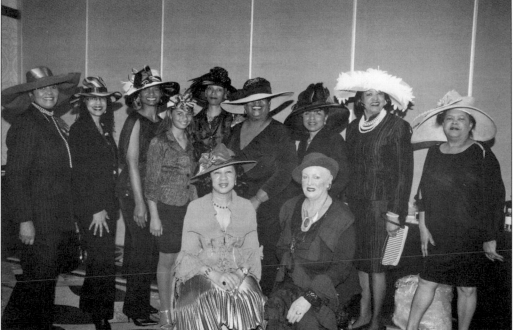

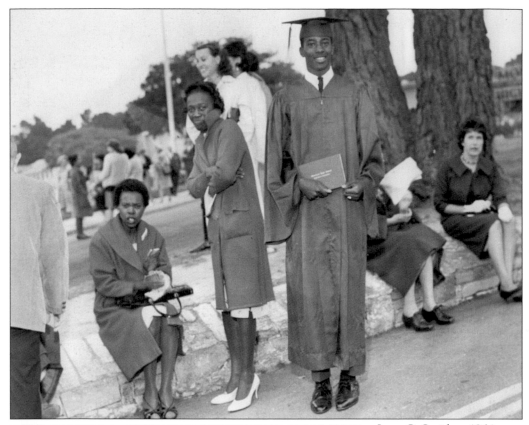

Vietnam Veteran

5th Div. Military Police Co. Sergeant

California Dept. of Corrections Peace Officer

Seaside, California Mayor

Monterey County 4th District Supervisor

*Jerry Smith*

Jerry C. Smith, a 1964 graduate of Monterey High School (above), served in the Army's military police division. He was elected mayor of Seaside (1998–2004). Before becoming mayor, Smith was hired by the California Department of Corrections as a correctional officer at Soledad Prison. In November 2004, Jerry Smith was elected as Monterey County's Fourth District supervisor and served as chairman. Smith was also a member of the Fort Ord Reuse Authority. Jerry Smith passed away in 2007. (Right, photograph by Leah Washington; both, courtesy of Velma Evans.)

Mel Masson, a graduate of Monterey High School, attended Monterey Peninsula College (MPC) in the 1960s, where he was an All-American in basketball. In 1996, Masson was inducted into the MPC Athletic Hall of Fame. Activism and community service are important to Masson, starting in the 1960s with his involvement in the Black Panther Party. He became a leader of the Socialist Party and ran for governor of California in 1982. He also served on the Seaside City Council from 1980 to 1984. Masson also served two terms as the president of the Monterey County NAACP beginning in 2002. (Both, courtesy of Mel Masson.)

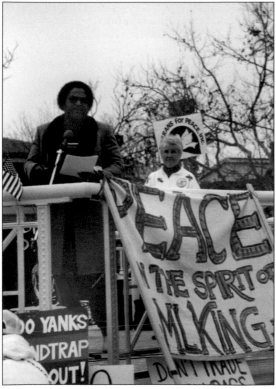

Mel (above) and Regina Masson founded the Village Project, Inc., in 2010, a community-based grassroots agency that focuses on providing family resources throughout the bay area and Los Angeles. It services children 12 to 18 in its afterschool program and provides mental-health treatment to former inmates returning to civilian life from prison through AB109, which reduces the overcrowded prison populations in California. Below, Regina Masson poses with Julian Bond. Regina, a community activist, child-welfare supervisor, and past commissioner for Monterey County's Commission on the Status of Women, has a passion for advocating fairness and equity to ensure that the needs of poor people are met. She is a Jefferson Award recipient. (Both, courtesy of Mel and Regina Masson.)

Author and therapist Ann Jealous (left) moved to California in 1967, when it was illegal in Maryland for interracial couples to marry. California was a welcoming place for interracial couples, so Fred and Ann Jealous moved to San Diego before relocating to the Monterey Peninsula. Fred and Ann raised their children, Ben and Lara Jealous, in Pacific Grove. Ann is the chair of the board for the Village Project in Seaside. Here, coauthors Ann Jealous and Caroline Haskell discuss *Combined Destinies*, a book about whites sharing grief about racism. (Photograph by Leah Washington, courtesy of Ann Jealous.)

Shown here is community activist Mary Claypool, president of the Monterey County NAACP. Claypool retired after 20 years of employment with the City of Seaside Redevelopment, Community, and Economic Development Agency. She has been a member of the NAACP since the 1980s, a member of the chamber of commerce, and has served as the chairperson of the Seaside Planning Commission. (Courtesy of Mary Claypool.)

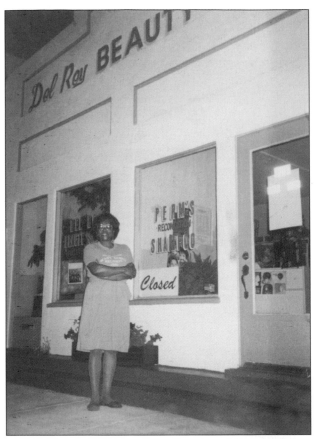

Delores Scaife-Higgins came to Salinas in 1964. She raised three sons and a daughter and opened the only black-owned business, Del Rey Beauty Salon, in Seaside on Alisal Street. She served on the Salinas City Council from December 1992 to June 1993; at the time, she was the first and only African American to serve on the council. Community service is important to Scaife-Higgins. She was the founder of the Salinas United Business Association and served as its treasurer. She is also a lifetime member of the NAACP. Here, Delores Scaife-Higgins standing in front of her shop. (Courtesy of Delores Scaife-Higgins.)

Josephine Morris (left) is one of 10 children of parents who worked on the farms from Arizona to California. As a child, Josephine recalls how her father, because of his race, struggled to find fieldwork. When Josephine and her husband, stationed at Fort Ord, move to Salinas, the first black family they met was Ignatius and Mattie Cooper. Since 1969, Josephine has volunteered at the juvenile hall, local jail, and the prison, and she still does so today. Josephine experienced racism in housing and employment, but, with her belief in God, she continues to assist others. Today, she continues volunteering and writing poetry. (Courtesy of Josephine Morris.)

Wellington Smith Jr., known as Wally, was the son of Rev. Wellington Smith Sr., who moved the family to the Monterey Peninsula in the early 1930s. Smith Jr. was a probation counselor at juvenile hall in 1957. In 1963, he was promoted to senior probation counselor. According to employees, Wally Smith displayed a dedication to the well-being and rehabilitation of the residents of the wards assigned to his care. He extended that dedication to the training and the development of a professional attitude among his coworkers. After 27 years, he was highly respected by the staff at juvenile hall. According to staff, workers and inmates referred to him as "Pops." In 1984, Wellington Smith suffered a heart attack on the job and passed away. After his passing, Monterey County renamed the juvenile facility the Wellington Smith Juvenile Detention Center of Monterey County. (Courtesy of the Wellington Smith Juvenile Detention Center of Monterey County.)

The Monterey Bay Chapter of the Links, Inc., was chartered in 1974 and continues as the main service organization for African American women. It documents more than 500,000 service hours annually. Its primary focus is service to youth, the arts, international trends and services, and health and human services. The Links have identified the primary focus on service to youth with "Linkages to H.E.A.L.T.H; Empowering Youth to Build Healthy Communities." Presently, the Links have identified 90-year-old Elizabeth Y. Smith (left) of Seaside for special honors, since she is the last living charter member from the Monterey Bay Chapter. Smith is the surviving wife of Airman Sherman Smith. Below is a recent photograph of members of the Links, Inc. (Both, courtesy of Monterey Bay Chapter of the Links Inc.)

Marla Anderson has served as a Monterey County judge since 1995. She is currently the presiding judge and handles the administration of the courts. Judge Anderson was appointed on January 13, 1995, and she has retained her seat ever since. Judge Anderson married Frederick Anderson of Hartnell College in the late 1970s, and they have raised three children. Judge Anderson expressed the need to find ways to encourage academic excellence in the youth throughout the county in order to prepare them for the real world. She also sees the need to establish a county-wide presence, not allowing just one city to define a culture. (Both, courtesy of Fred and Marla Anderson.)

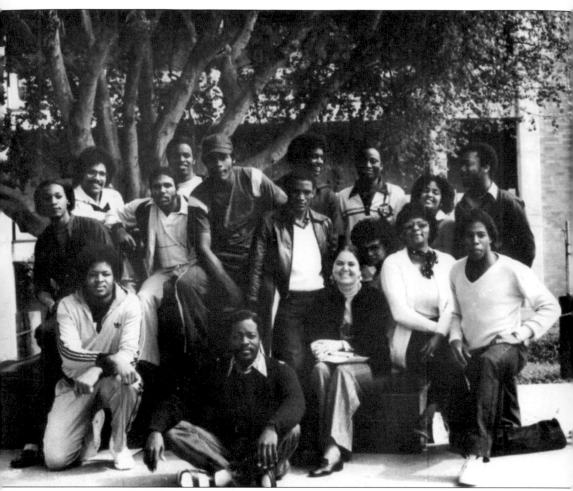

Prof. Frederick Anderson, who taught computer science and library science courses, helped to initiate the ethnic studies department at Hartnell College in the 1970s. Shown here are the members of the United Black Students in 1979. Those identified are, in the first row, V.P. Lucende Mooney, Delores Scaife-Higgins, and Cindy Obenchara; in the top row at left are Fred Anderson and Walter Ryce; others are unidentified. Frederick Anderson retired from Hartnell College in 2001 after 25 years as a tenured professor. He is the senior pastor of the Seaside Community Seventh-Day Adventist Church on Broadway Avenue. (Courtesy of Fred and Marla Anderson.)

*Five*

# THE NEXT GENERATION OF SUCCESS

Many descendants of African American pioneers have chosen to continue the leadership they learned, either in Monterey's communities or elsewhere. According to Pvt. Jazmine Kemba Blakeney-Green (right), age 19: "Our life is governed by the choices we make. The strong women and resilient men that have raised me, I am proud to call family. . . . The generations to come . . . [must] look back and remember how they got here and where they are going." (Courtesy of Pvt. Jazmine Kemba Blakeney-Green.)

S. Rudy Martin Jr. is the son of Primrose and S.R. Martin Sr., the founder of Victory Temple Church of God in Christ. S.R. Martin Jr. lives in Olympia, Washington, and is the author of *On the Move: A Black Family's Western Saga and Seaside Stories*. A graduate of Monterey High School and UC-Berkeley, Martin Jr. currently holds a tenured faculty position at Evergreen State College. (Courtesy of S.R. Martin Jr.)

Dan Martin, son of Primrose and S.R. Martin Sr., joined the Seaside Police Department and worked with Seaside's youth. He earned a law degree and relocated to San Jose, California. (Courtesy of Dan Martin.)

Leah Washington's mother, Adine Williams, said that Leah was almost born in the dark room at Camera Masters, the first black-owned studio on the peninsula. Leah has continued in her mother's footsteps in the photography business. A graduate of Monterey High School, Washington earned her bachelor of arts from Santa Barbara's Brooks Institute of Photography and an master of arts from San Jose's Institute of Graphics. A photographer, Washington continues her mother's business slogan: "We make you look good around the world." (Courtesy of Leah Washington.)

Community leader Darryl I. Choates, of the Niblett family, is a graduate of Seaside High School and Monterey Peninsula Community College. He was elected at 27 years old to Seaside's city council, the youngest person elected to that body. Choates served for 16 years. He owns and operates the Ord Market and coaches Little League baseball. His major contribution is the establishment of the Girls and Boys Club and the Seaside Youth Education Center in Monterey County. (Courtesy of Darryl I. Choates.)

Ben Jealous, former president of the national office of the NAACP, son of Anne and Fred Jealous, was born in Pacific Grove and attended elementary school, middle school, and high school on the Monterey Peninsula. He believes that his sense of social justice began as a child living in Pacific Grove. Specifically, he recalls when, in elementary school and visiting the public library, he was not able to find books by or about African Americans. He recalls walking up to the librarian and asking why books about black Americans were not in the library. With this request, the library promptly added books about African Americans to its collection in preparation for Black History Month. In high school, Jealous spearheaded the NAACP's voter registration drive throughout Monterey. He continued advocating for justice while at Columbia University. Today, Ben Jealous is a national civil rights leader concerned with voting rights and insuring justice for all. (Courtesy of Leah Washington.)

Ray Drummond, son of Airman Charles H. Drummond Jr. and Doris Drummond, is a world-renowned jazz bassist, recording artist, and music teacher. Even though Ray has always loved music, his love for the bass began when his high school music teacher encouraged him to play it. Drummond completed his bachelor of arts degree and then earned a master's in business administration from Stanford University. He has taught music at Monterey Peninsula College as well as at several colleges and universities throughout the country. He has also performed at the Monterey Jazz Festival and the Stanford Jazz Workshop. He has recorded and performed with several accomplished musicians from all over the world. (Courtesy of Mary Anne Drummond.)

David Drummond, son of Airman Charles H. Drummond Jr. and Doris Drummond, grew up in Monterey with five siblings. A graduate of Monterey High School, David earned his bachelor's degree from Santa Clara University and his juris doctorate from Sanford Law School. He is currently a senior vice president and chief legal officer at Google. (Courtesy of Ray Drummond.)

Marcus Nance, son of Rev. Richard Nance and Esther Nance, is a world-renowned stage performer and vocalist who has performed across Canada and the United States. Born in Pacific Grove, Nance graduated from Pacific Grove High School in 1982 and attended Fresno State University. He attended First Baptist Church in Pacific Grove along with his parents and three siblings. (Courtesy of Marcus Nance.)

Marcus Nance has performed on Broadway as Caiaphas in the musical *Jesus Christ Superstar*. He has also performed other roles for the Stratford Shakespeare Festival. The *New York Times* describes Marcus as "a thrillingly powerful bass-baritone." *Backstage NY* has described his voice as "a bass that flows like melted butter." Nance currently lives in Toronto, Canada. (Courtesy of Marcus Nance.)

James Rucker, son of James Sr. and Helen Rucker, attended Santa Catalina and Robert Louis Stevenson schools. After graduating from high school, James enrolled in Stanford and completed his bachelor's and master's degrees. After college, he became a software developer and began a startup, Colors of Change, to respond to Hurricane Katrina. Rucker attributes his success to high expectations on the part of his parents. Helen and James Sr. were public-school educators who were passionate about education and expected him to go to college. James Rucker remembers the coastal communities of Monterey as a safe place for black children to grow up; most of the black families were middle class, well educated, and had a military influence. (Courtesy of James Rucker.)

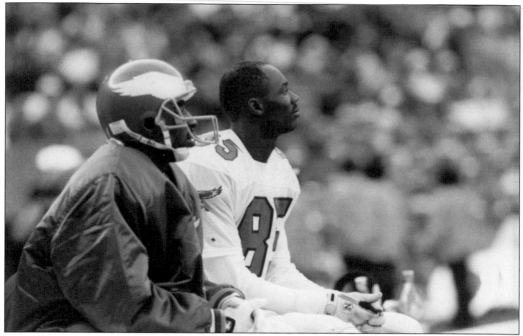

Ron Johnson (above, right), one of May Johnson's four sons, grew up in a quiet, middle-class neighborhood of Monterey. He graduated from Monterey High School, where he played basketball and football and ran track. Johnson joins a group of young men of the Monterey Peninsula who have achieved great success in professional sports, including Herman Edwards, Paul Joyce, M.L. Carter, Herb Lusk, Orlando Johnson, Robbie Johnson, and Terrell Sherman. Ron Johnson played college football at MPC and Long Beach State University. From 1985 to 1989, he played for the Philadelphia Eagles. Today, he is a vice president for the Boys and Girls Club of Salinas and Monterey. Johnson believes that success happens with perseverance, stability, and hard work. "Nothing comes easy in life," he says. In the below photograph, Ron (far left) stands with his brothers, from left to right, Kenneth, Robert, Andre, and Edwin. (Both, courtesy of May Johnson and Ron Johnson.)

Maj. Gen. Mary Josephine Green Kight, the oldest of four children of James and Socorro, grew up in Monterey. She is pictured posing with Gov. Arnold Schwartzenegger above. She graduated from Monterey High School and received her bachelor's degree from Chico State University in 1973. That year, she and her husband, Bradley Kight, enlisted in the US Air Force, and Mary served until she retired in 2011. From 2006 to 2011, Major General Kight served as the adjutant general for the California National Guard's federal and state missions. Kight received the Distinguished Service Medal for her military career. For her, the military provides the opportunities for women of color to demonstrate their abilities. As a retired veteran, Kight's passion is to reach out to veterans who served before her. Major General Kight says, "I stood on their shoulders to reach success, now I can serve them in return." (Both, courtesy of Douglas Sutton.)

Maj. Gen. Mary Kight has fond memories of growing up in Monterey. She believes it was the village, a community of caring adults from among family and friends and teachers, who mentored and nurtured her. In return, she shares this support with others. Today, Mary and her brothers follow in their parents' footsteps and provide that same sense of village to the many family members and friends in their lives. Standing behind Mary in the left photograph are her brothers, from left to right, Paul, Milchor, and Randy. The below photograph shows Milchor's moving team, which was hired to move newly elected Ronald Reagan to Washington, DC. Milchor is standing in the back, second from left. (Both, courtesy of Major and Socorro Green family.)

After the presidential election of 2008, the leaders of Seaside worked together to change the name of Broadway Avenue to Obama Way. The above photograph shows the members of the committee who worked to make this change. Facing front are, from left to right, Ruthie Watts, Rev. Herbert H. Lusk, Morris McDaniel, Yolanda Grimble, Helen Rucker, Alyce Jordan, Don Jordan, Kathy Badon, Sondra Lackey, and Carlos Ramos. (Courtesy of Leah Washington.)

# Discover Thousands of Local History Books Featuring Millions of Vintage Images

Arcadia Publishing, the leading local history publisher in the United States, is committed to making history accessible and meaningful through publishing books that celebrate and preserve the heritage of America's people and places.

## Find more books like this at
## www.arcadiapublishing.com

Search for your hometown history, your old stomping grounds, and even your favorite sports team.

Consistent with our mission to preserve history on a local level, this book was printed in South Carolina on American-made paper and manufactured entirely in the United States. Products carrying the accredited Forest Stewardship Council (FSC) label are printed on 100 percent FSC-certified paper.

MADE IN THE